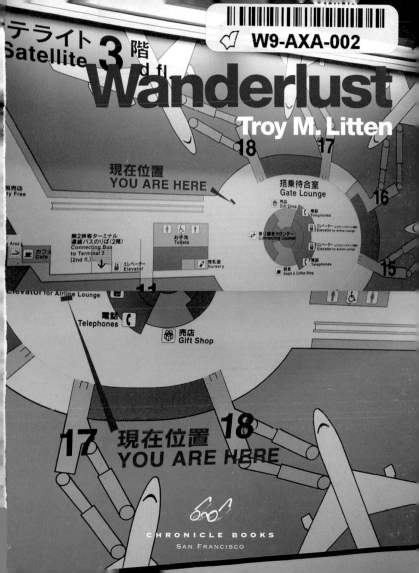

Wanderlust

Troy M. Litten

CHRONICLE BOOKS
SAN FRANCISCO

VOCÊ ESTÁ
AQUI

* You are here

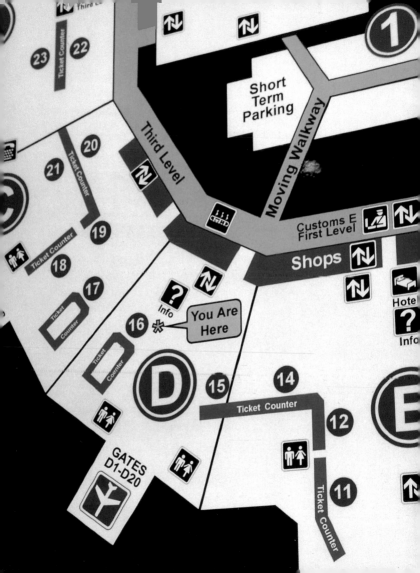

Historic P

RD.

YOU
ARE
HERE

4

X

HWY.

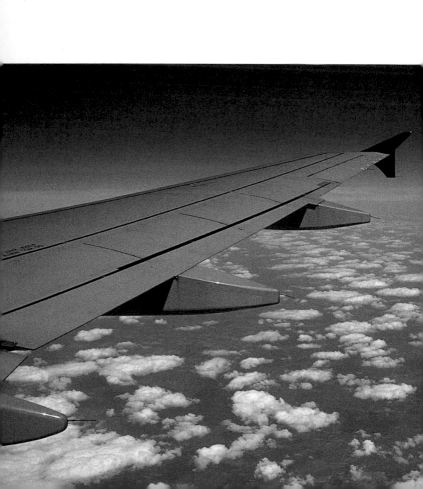

11
Cruising Altitude

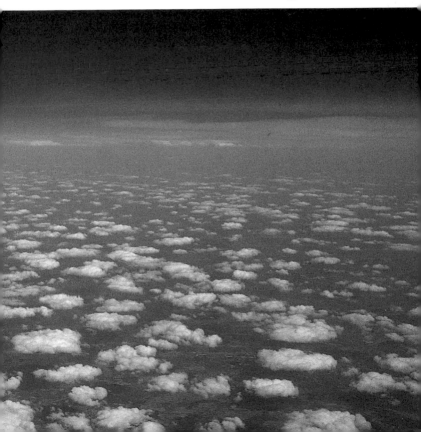

Top left board

RALEIGH/DURHAM	1761		8:55P	ONTIME	0
ROCHESTER	3616		4:55P	BRDING	0
ROME	40	AZO641	2:50P	ONTIME	0
SAN ANTONIO	765		5:30P	ONTIME	0
SAN DIEGO	103	NW6103	6:50P	7:02P	ONTIME 0
SAN FRANCISCO	157	NW6157	5:15P	ONTIME	0
SAN FRANCISCO		OK4096	5:15P	ONTIME	0
SAN JOSE.C.RICA	779	NW6779	5:20P	ONTIME	0
SAN JOSE.CALIF.	449	NW6449	5:40P	6:35P	ONTIME 0
SAN JUAN	745	NW6745	6:55P	ONTIME	0
SARASOTA	401		4:10P	BRDING	0
SAVANNAH	4023		4:35P	BRDING	0
SEATTLE/TACOMA	125	NW6125		BRDING	

Top right board

09:55	Damascus	RB	434	T6	Vertrokke
10:15	Puerto Plata	MP	605	T6	Vertraagd
10:30	Lima	AZ	3670		Instappen
10:50	Los Angeles	KL	6055		Instappen
11:20	Rome	KL	4541	T2	Instappen
11:30	London Hrow	VS	4104	T5	Instappen
11:35	Washington	KL	6037		Instappen
11:45	London Hrow	QF	3431	T5	Vertrokker
11:45	London Hrow	CP	5003	T5	
11:45	Zagreb	OU	451	T6	Instappen
11:45	Leedsbrdford	UK	2165		Instappen

28ゲート出発便ご案内 / Departures 14 56

ゲート GATE	出発時刻 DEPARTURE	便名 FLIGHT NO.	備考 REMARKS	
28A	15:55	KE 2	定刻	ON TIME
8E	17:45	NW 19	定刻	ON TIME
E	17:45	C05019	定刻	ON TIME
D	18:10	NW 21	定刻	ON TIME
	18:10	C05021	定刻	ON TIME

DEPARTURES

FLIGHT	TIME	GATE	DEPARTING TO	STATUS	FLIGHT	TIME	GATE	DEPARTING TO	STATUS
TH 924	6:20P	21	PARIS	CLOSED	TH 880	9:45P	26	CAIRO	ON TIME
UN 18	6:30P	27	MADRID	CLOSED	K3 262	10:00P	27	AMMAN	ON TIME
TH 3914	6:40P	32	BOSTON	CLOSED	TH 804	10:30P	31	TEL AVIV	ON TIME
TH 3935	6:40P	32	WASHINGTON D.C.	ON TIME					
TH 842	6:45P	32	MILAN	ON TIME					
TH 3907	6:50P	32	NORFOLK	ON TIME					
TH 3947	7:25P	32	WASHINGTON D.C.	ON TIME					
TH 3852	7:40P	32	PITTSBURGH	ON TIME					
TH 233	7:40P	37	HARTFORD	ON TIME					
TH 46	7:55P	32	ST. LOUIS	ON TIME					
TH 900	7:55P	24	SAN FRANCISCO	ON TIME					
TH 3927	8:00P	32	LISBON	ON TIME					
TH 3937	8:00P	32	BALTIMORE	ON TIME					
TH 049	8:00P	22	WASHINGTON D.C.	ON TIME					
TH 3949	8:20P	32	LOS ANGELES	ON TIME					
TH 707	9:00P	21	WASHINGTON D.C.	ON TIME					
			ORLANDO						

TIDAS

DESTINO / DESTINATI

/FLIGHT

ARG	1251	BUENOS AIRES
LAN	0751	SANTIAGO
BAW	0246	LONDON
TAP	1554	OPORTO
ARG	1257	BUENOS AIRES
AAL	0950	NEW YORK
COA	0094	HOUSTON
		MIAMI

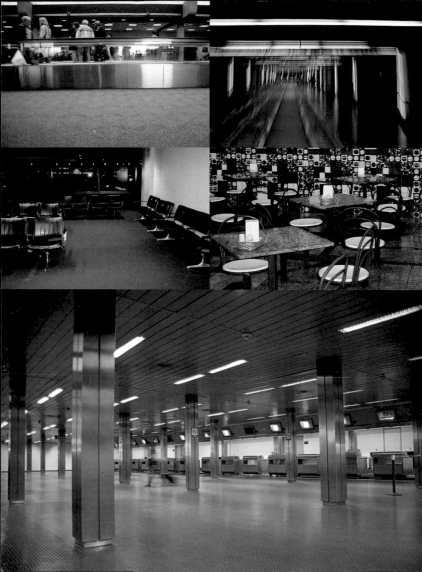

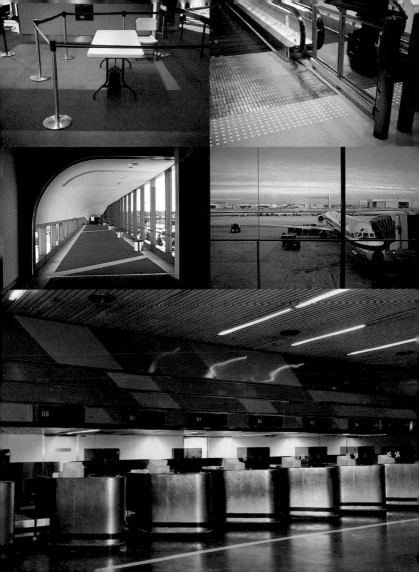

BOARDING PASS

NOMBRE DEL PASAJERO/*NAME OF PASSENGER*
LITTEN/TROYMR

X/O DESDE/*FROM*
RIO JANEIRO GIG
X/O A/*TO*
BUENOS AIRES EZE
AEROLINEAS ARGENTINA

TRANSP. NUM. VUELO / CARRIER FLIGHT	CLASE / CLASS	FECHA / DATE	HORA / TIME
AR 1251	Y	17 JAN	1240P

PUERTA/*GATE*	HORA/*BOARDING TIME*	ASIENTO/*SEAT*	FUMADOR/*SMOKE*
9	1210P	11A	NO

INFORMACION ASIENTO AD./*ADDITIONAL SEAT INFORMATION*

N° B PESO / PCS CK. WT.	NO FACT / UNCK. WT.	N° SEC / SEQ. NO.	
		011	B

ID DE EQUIPAJE NUM./*BAGGAGE ID NR.*

DOCUMENTO NUMERO
DOCUMENT NUMBER

BOARDING PASS

BOARDING PASS

NAME OF PASSENGER

LITTEN/TROY

X/O FROM

BUENOS AIRES EZE

X/O TO **MIAMI INTERNTNL**

AMERICAN AIRLINES

AA808 N 22 JAN 1050P

| CARRIER | FLIGHT | CLASS | DATE | DEPARTURE TIME |

3 GATE **1005P** **21G** NO SMOKING

 SEAT

GROUP 5

| PCS CKD | WT CKD | WT U'CKD | A/L CODE | BAGGAGE NUMBER |

| CPN | AIRLINE CODE | FORM AND SERIAL NUMBER | CK |

IDENT. ISS. CARRIER/AGENT

EZE

SECURITY CHECKPOINT 36 EZE 1A

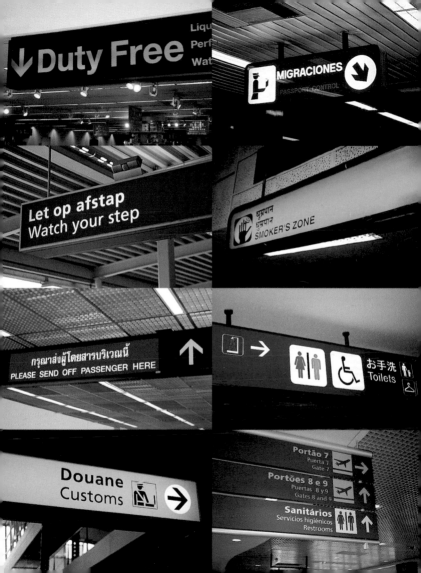

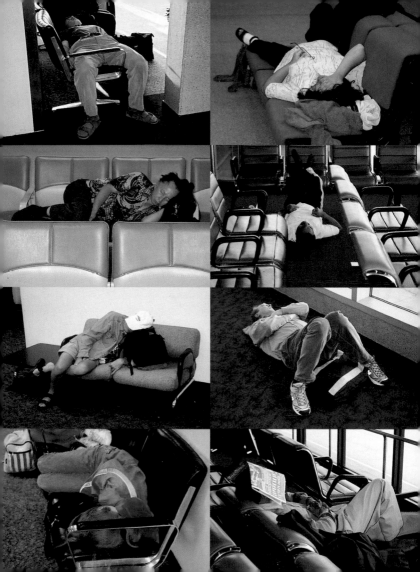

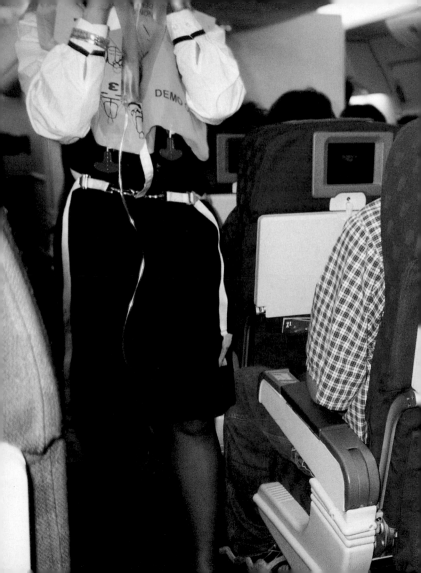

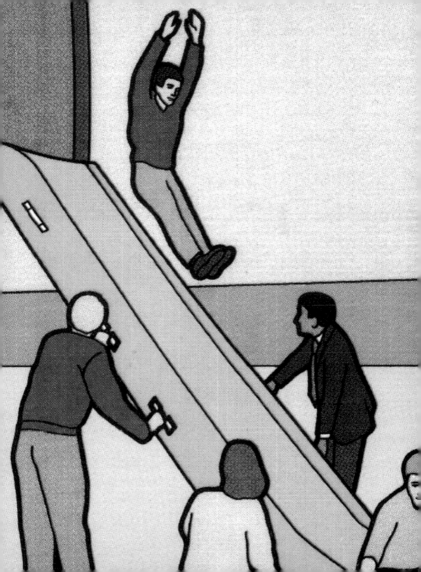

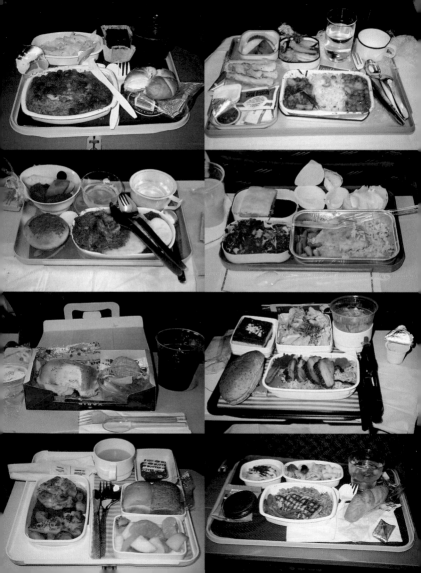

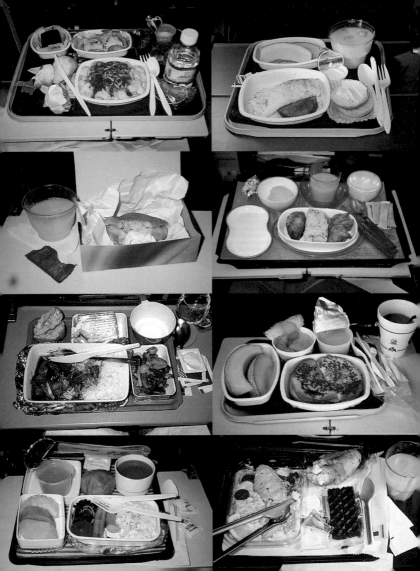

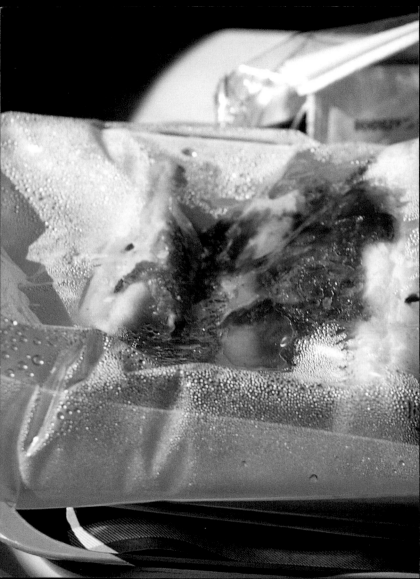

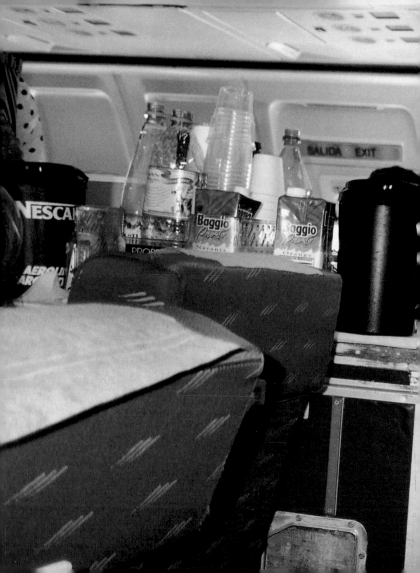

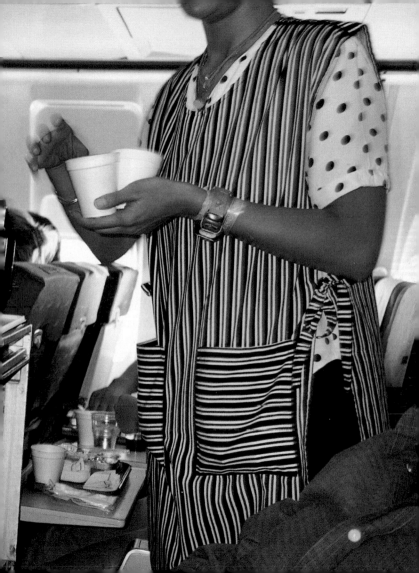

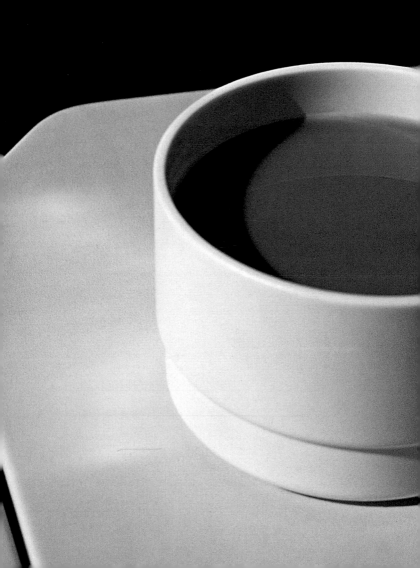

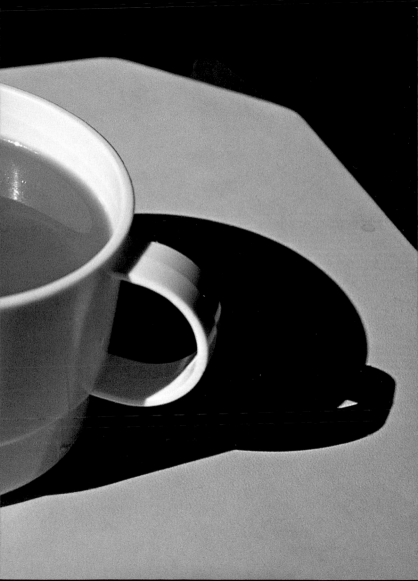

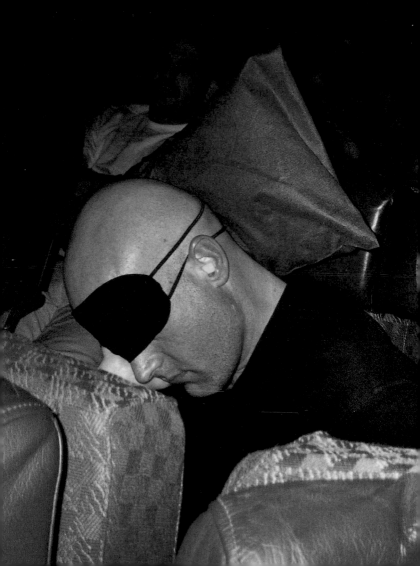

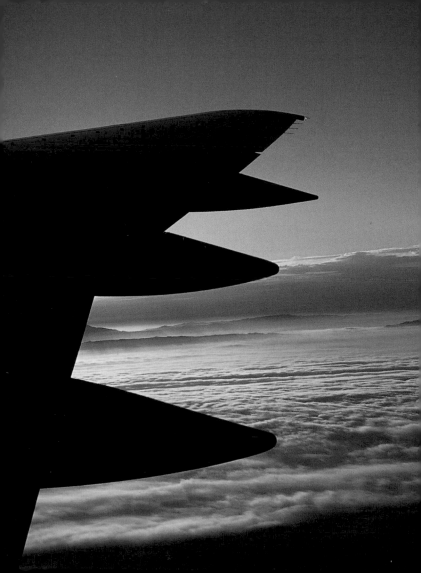

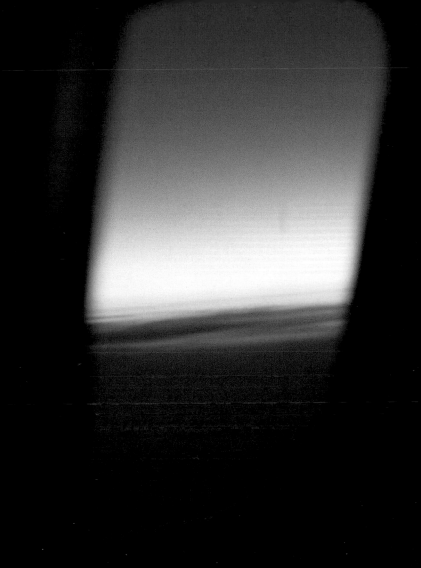

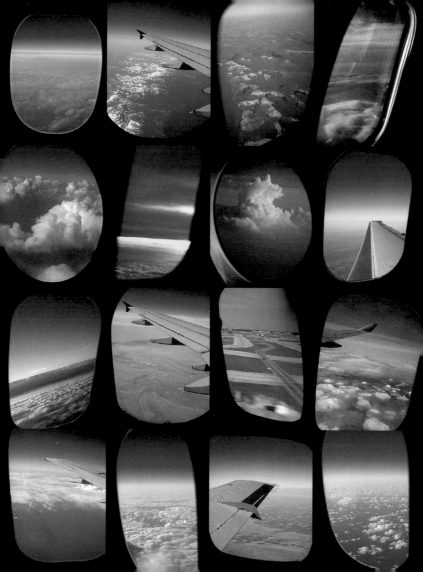

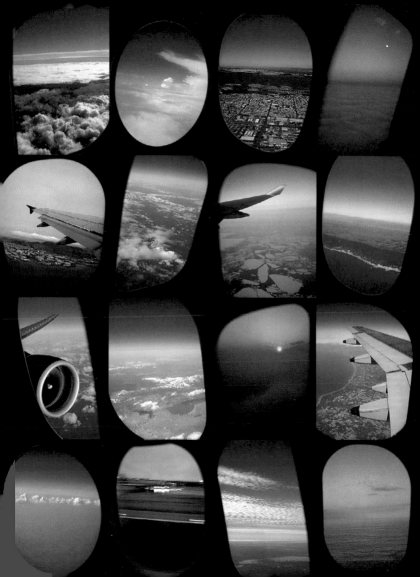

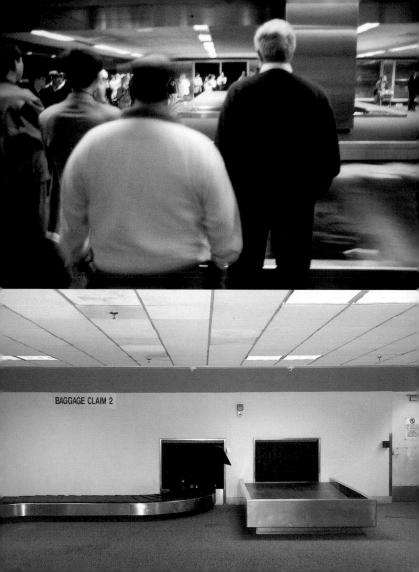

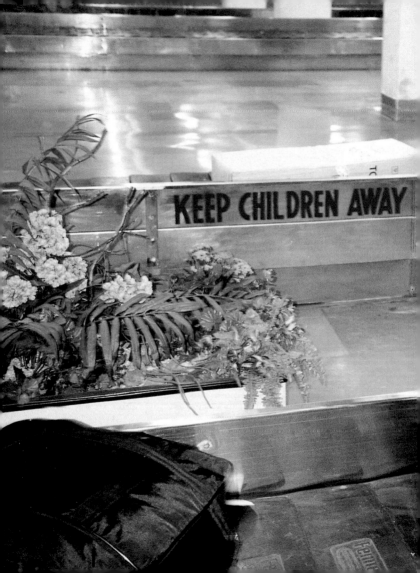

43
A Room for the Night

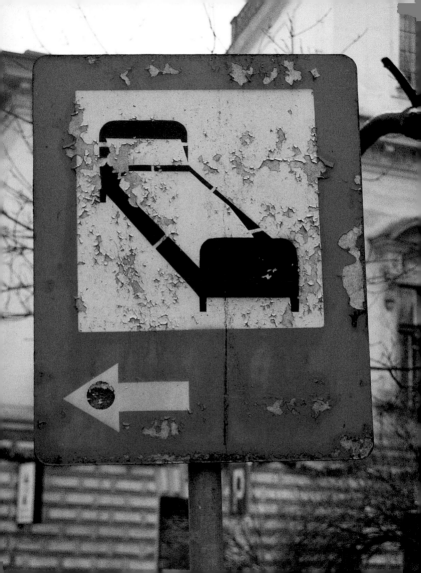

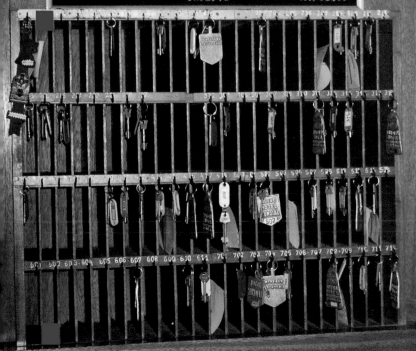

ИНТУРИСТ **HOTEL LIETUVA**

Vilnius, 232600, Ukmergės str. 20, tel. 35 60 74

GUEST CARD
GASTEKARTE

You can get your key producing this card.
Aushandigung des Zimmerschlussels nur gegen Vorlag dieser

Number of the room Zimmer — Nr.	619 V

Name
Familienname *Mitchell*

Reception Tel: 35 60 90.

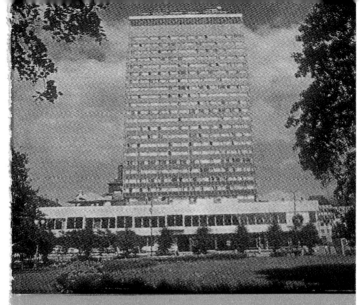

Riga Intourist
HOTEL
LATVIJA

ИНТУРИСТ

фамилия
name

комната
room No 1706

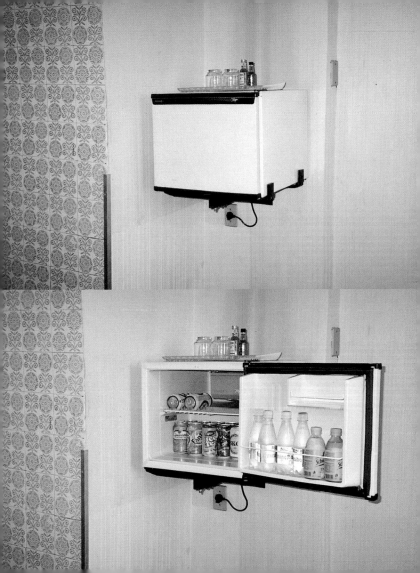

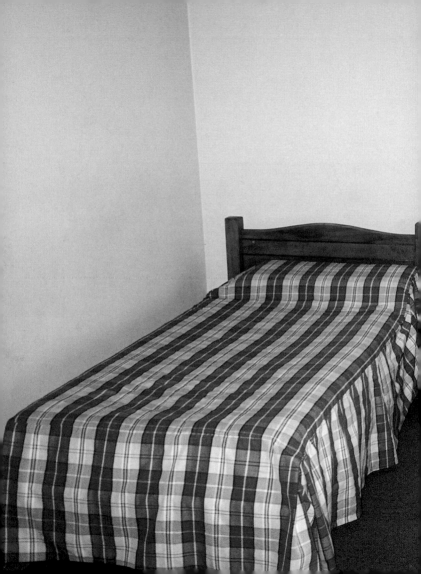

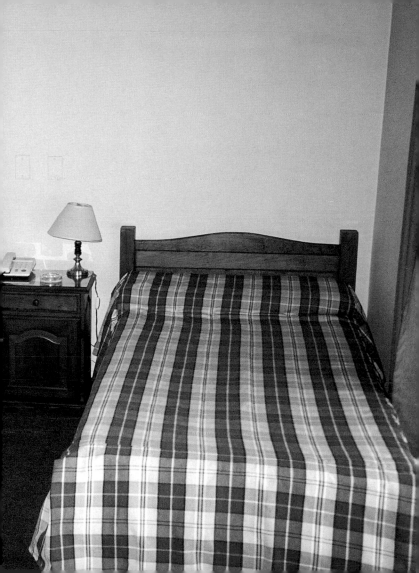

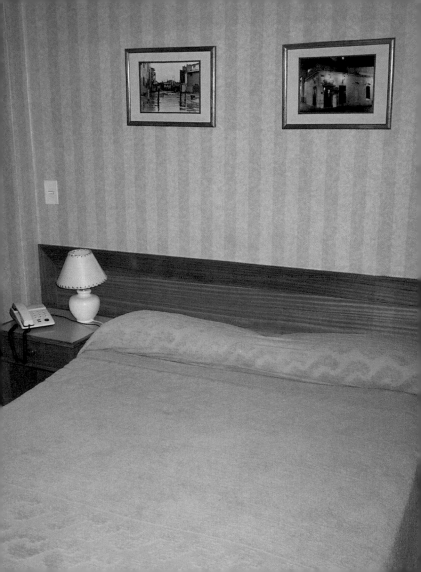

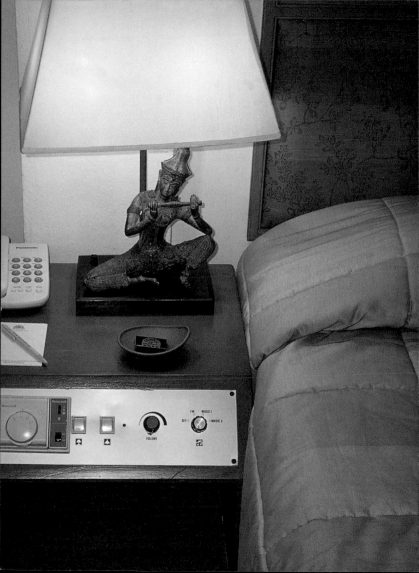

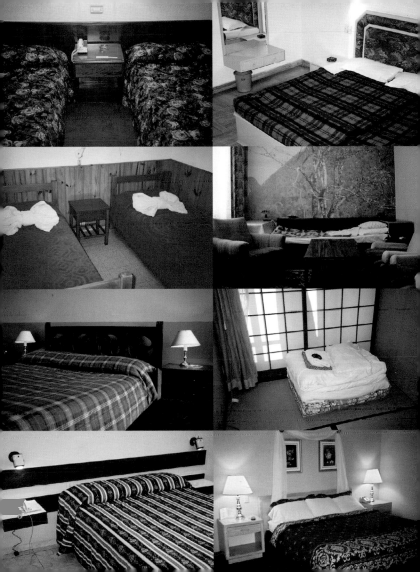

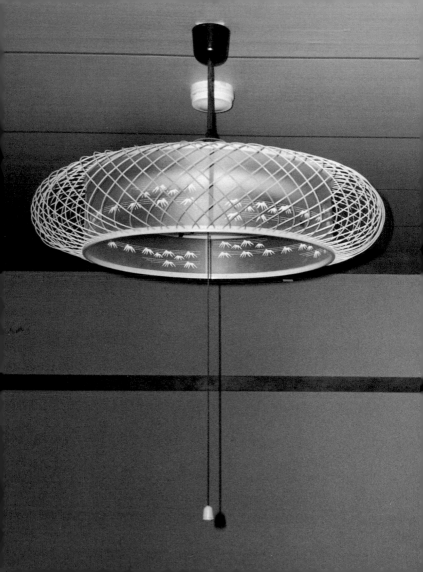

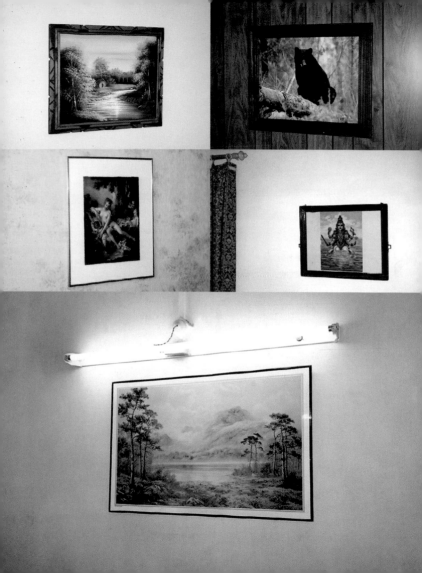

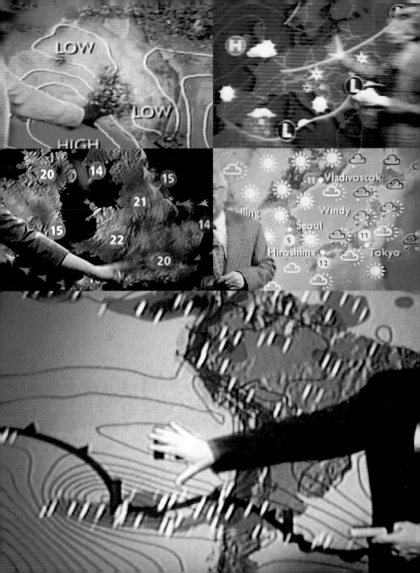

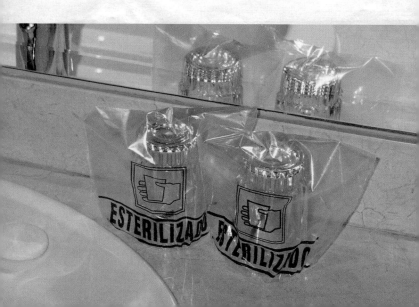

Bath & Shower Cap

国泰饭店
GUOTAI HOTEL

**Please
Do Not
Disturb**

Please
clean
my room

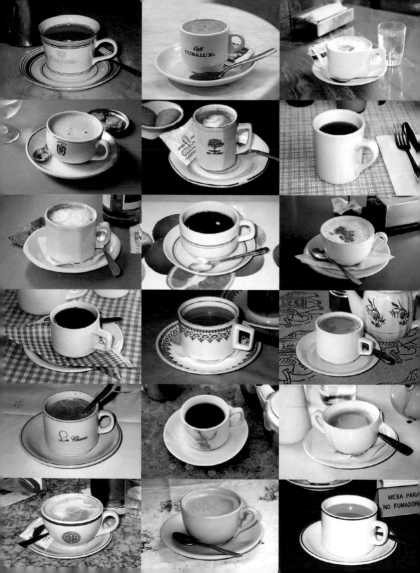

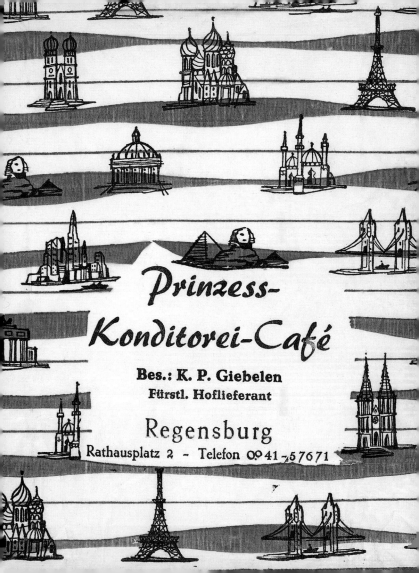

Prinzess-
Konditorei-Café

Bes.: K. P. Giebelen
Fürstl. Hoflieferant

Regensburg
Rathausplatz 2 - Telefon 09 41 - 5 76 71

...rro (Fiambre)	750	Champiñ... ajillo ó plancha
...pescados	1400	Callos
...mares ...ritos	900	Habas con Jamón
...llo ...allego	660	Chopi... Fritos
...las ...ó plancha	1200	Zort... española
...eso ...allego	900	Chul... de cordero
...ana...a ...allega	660	Jamón
...e mes	800	M...jill...

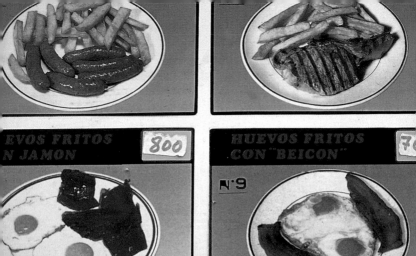

EVOS FRITOS
N JAMON 800

HUEVOS FRITOS
CON "BEICON" 7

Nº9

LOMO Y HUEVO 800

HUEVOS
CON JAM

·7 Nº8

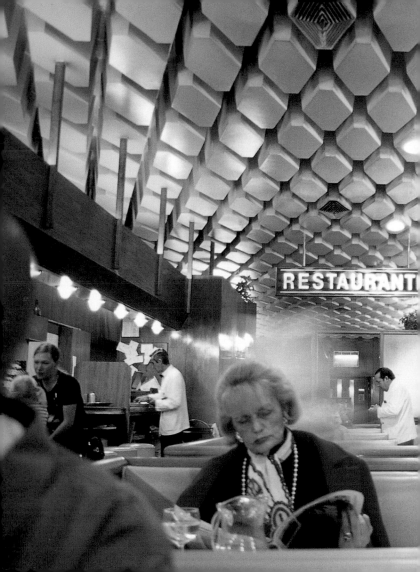

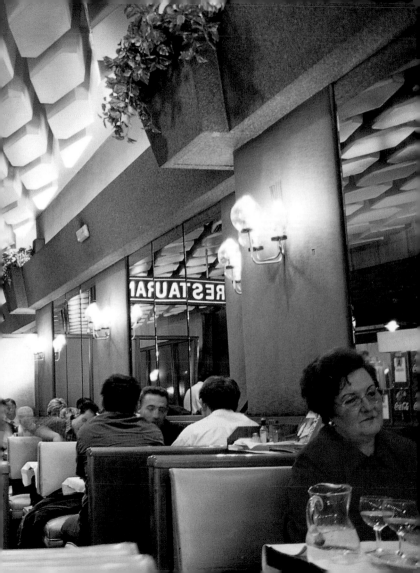

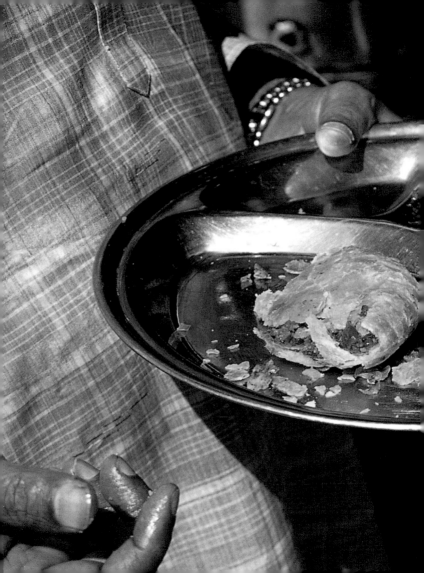

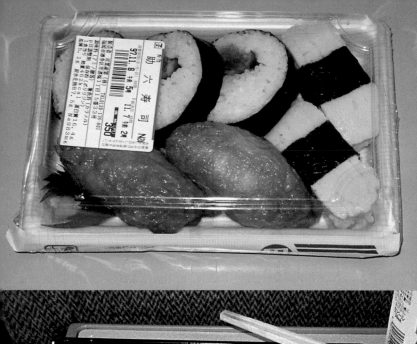

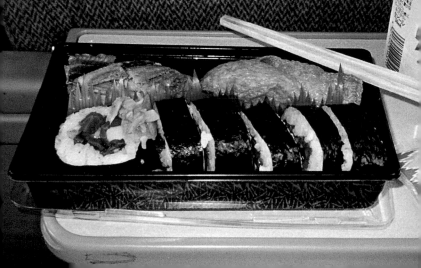

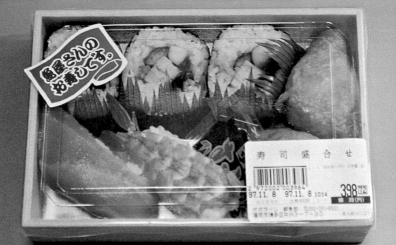

寿司盛合せ

2 972002003984

97.11. 8 97.11. 8 1014

398

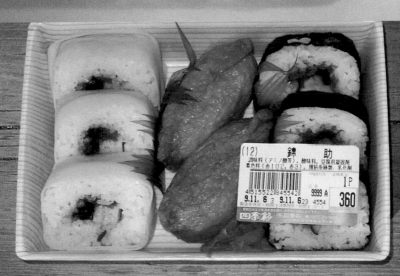

(12)　　錦　助

4 515522 845542 9999 A

9.11. 6 3 9.11. 6 23 4554

1P

360

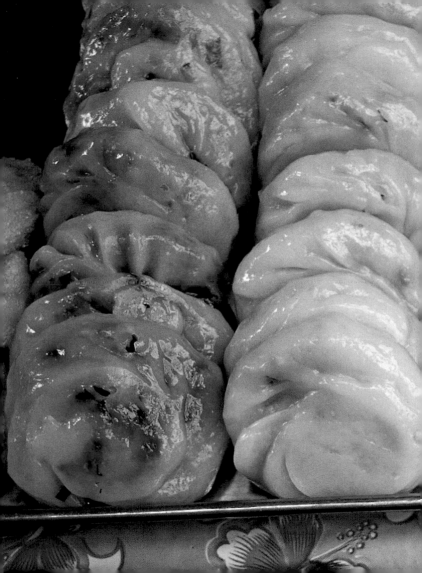

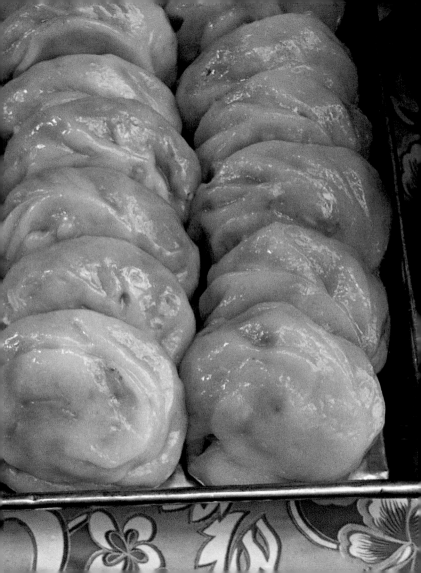

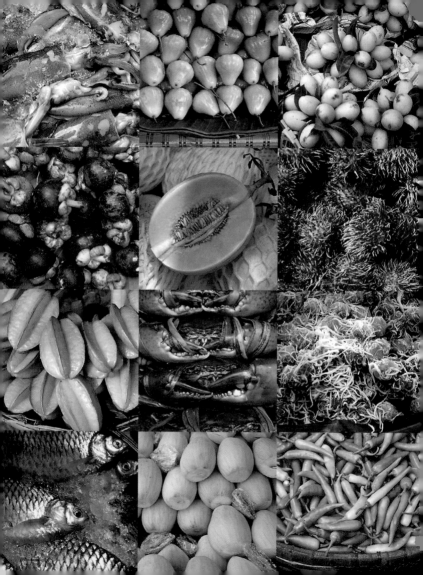

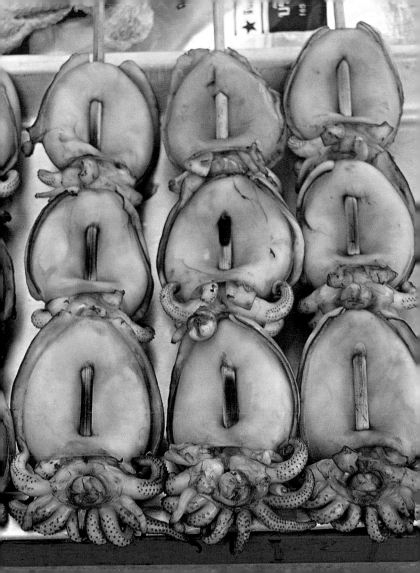

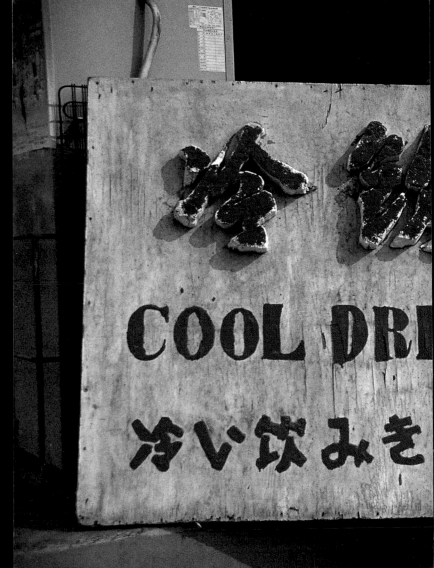

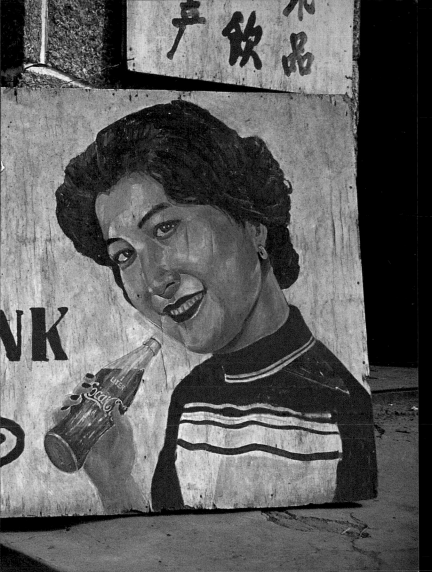

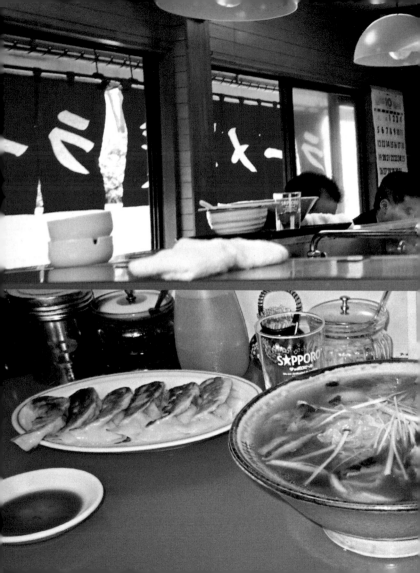

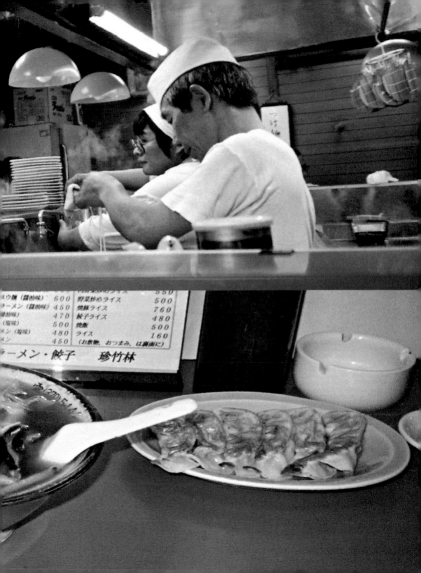

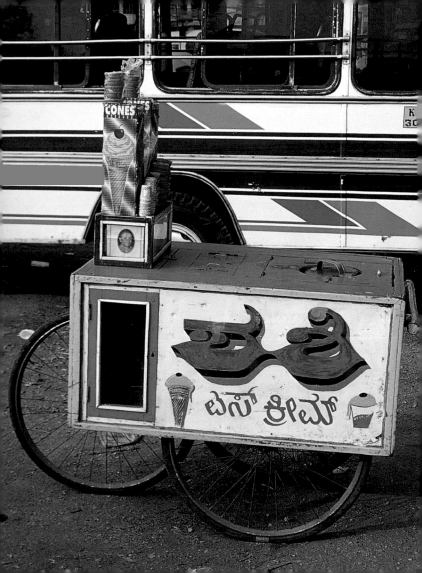

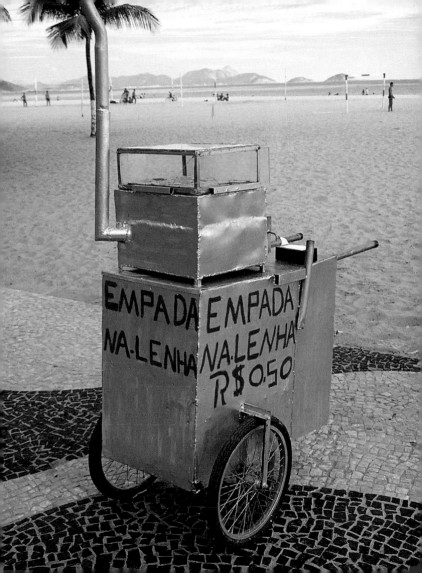

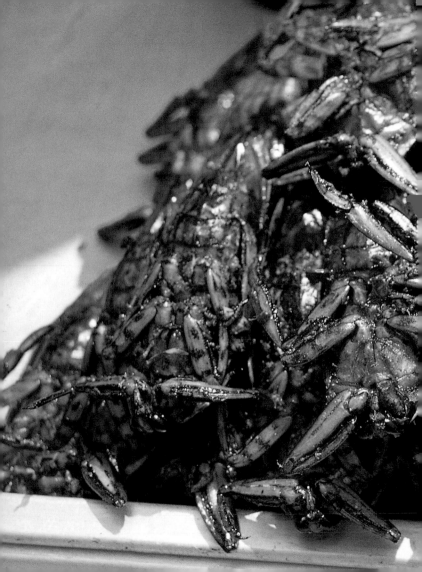

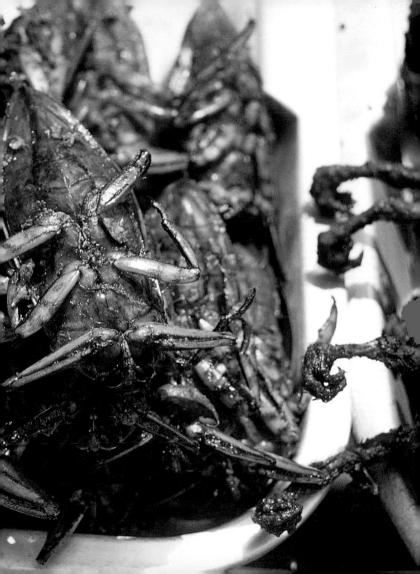

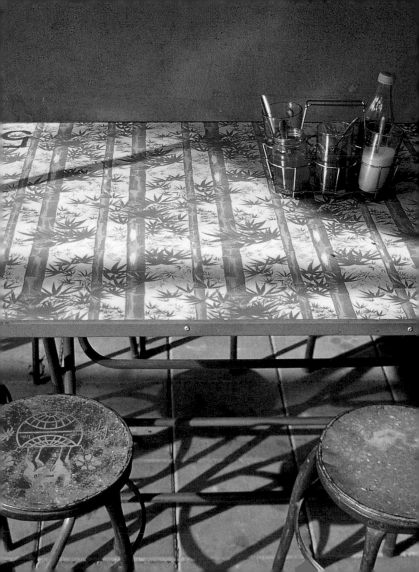

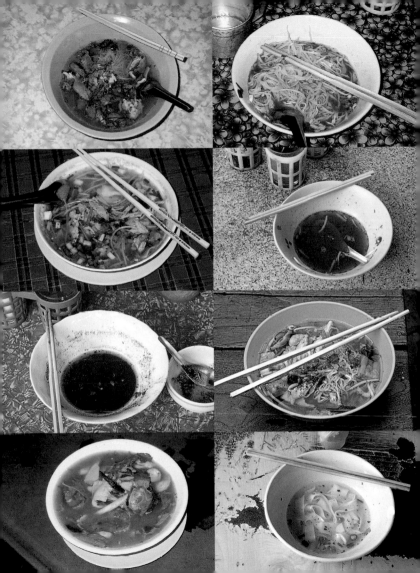

MADE IN NEPAL

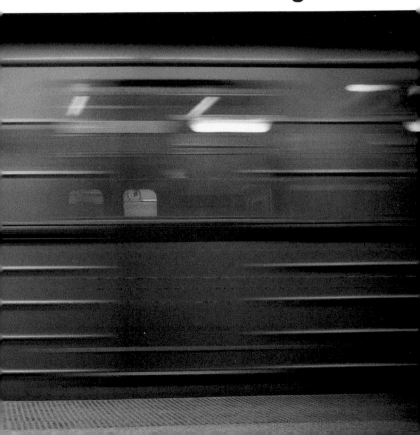

107
Getting Around

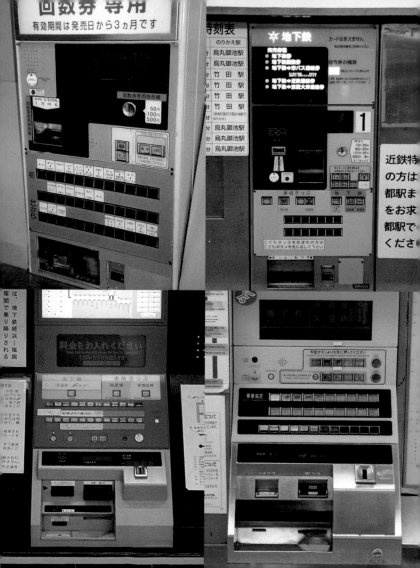

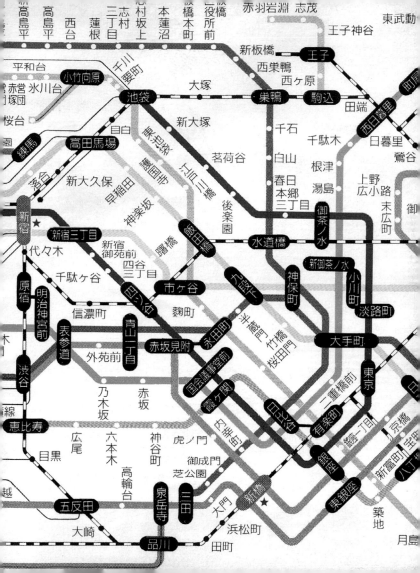

CARTE ORANGE

RATP SNCF APTR

nom
prénom **LITTEN, TROY**

signature

COUPON
JAUNE 2CL

N°:
semaine du
11 DEC
1-2
coupon
hebdomadaire

5923 ← **N° à reporter sur le coupon**

rangez ici votre coupon

prenez-en soin

ne le pliez pas et ne l'introduisez pas dans les composteurs des autobus

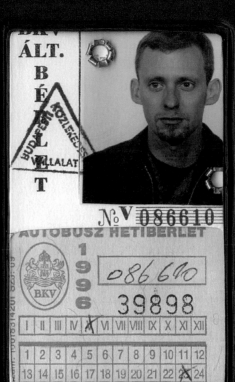

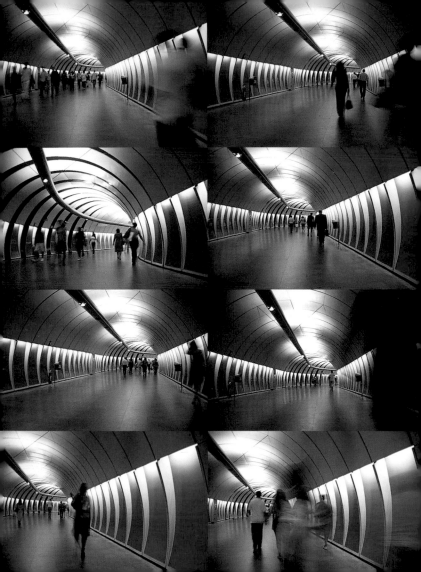

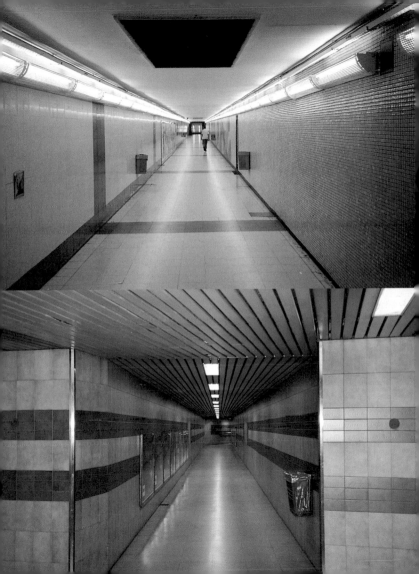

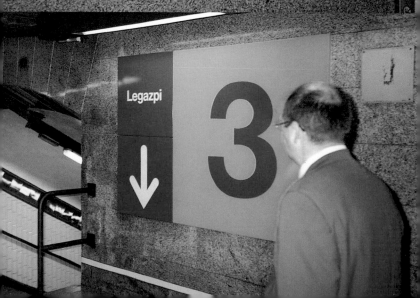

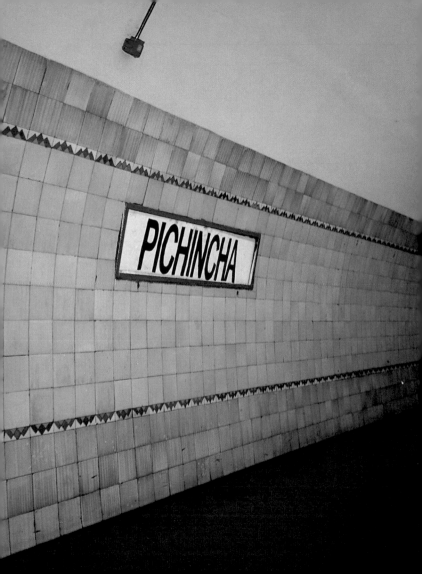

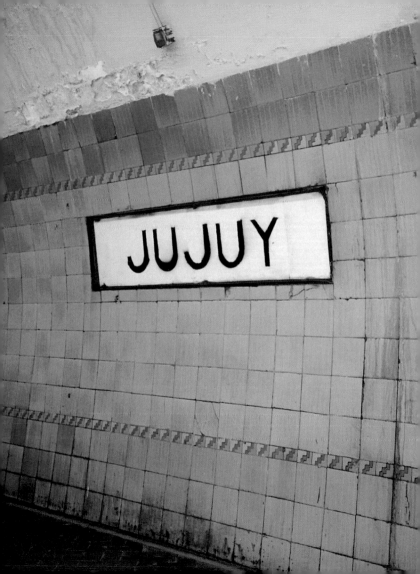

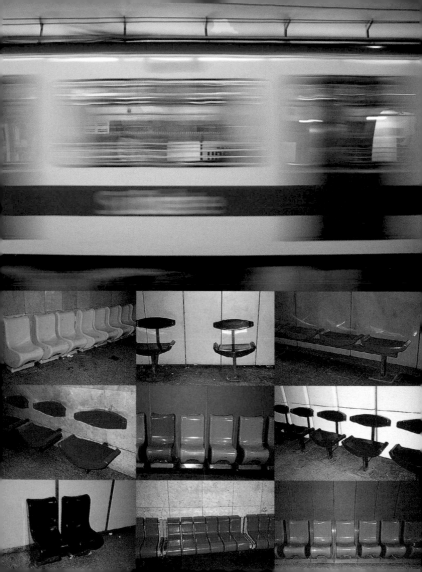

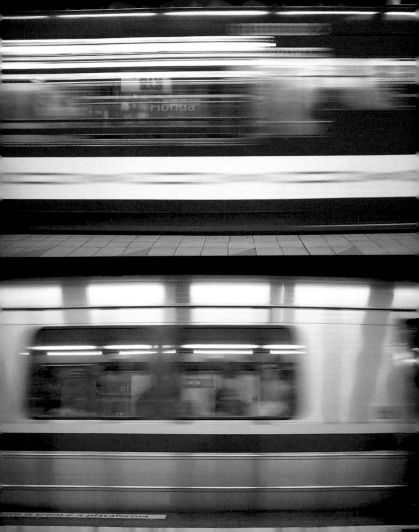

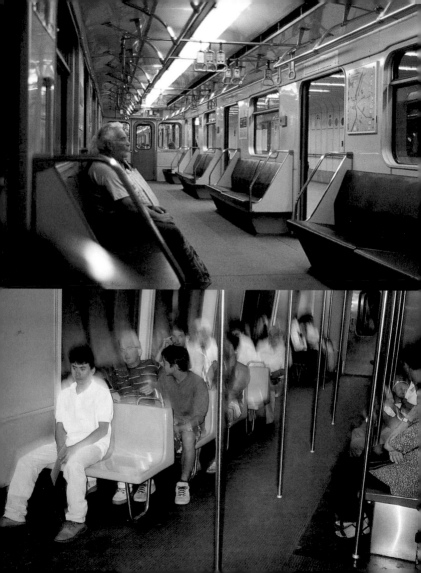

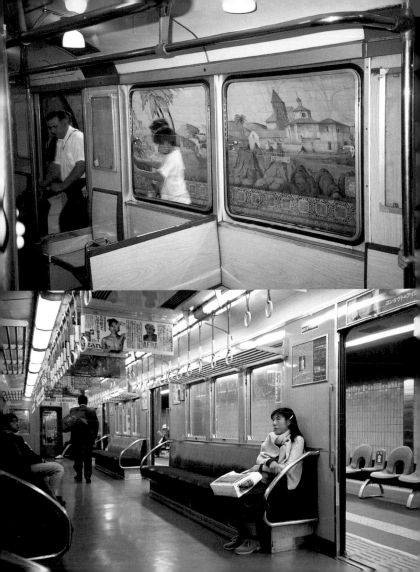

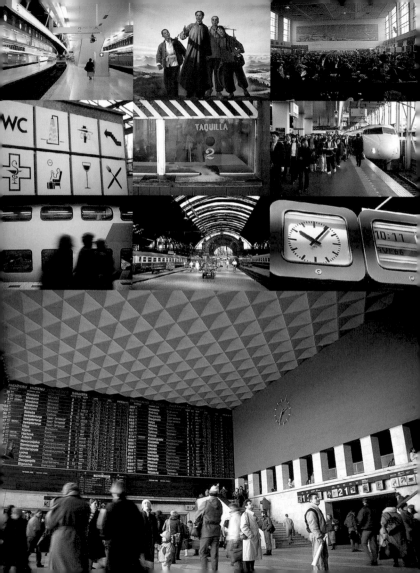

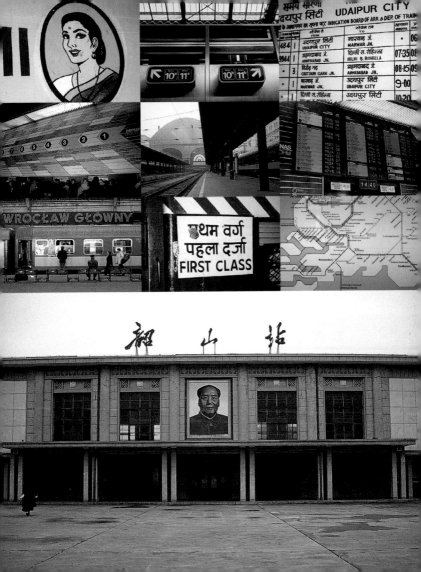

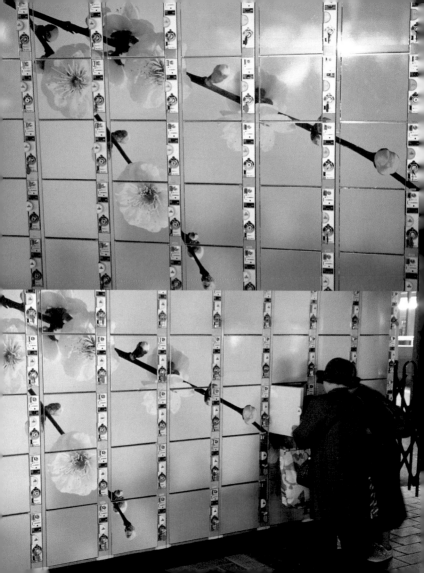

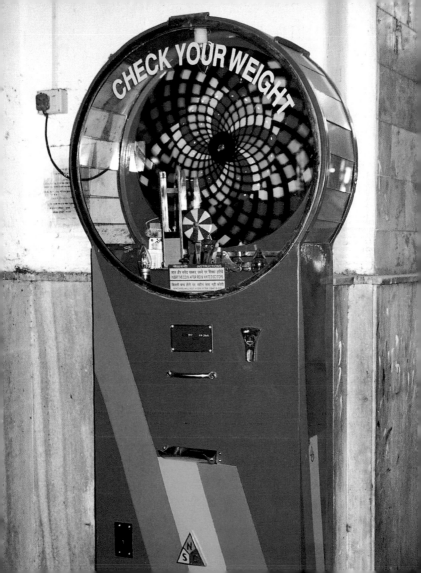

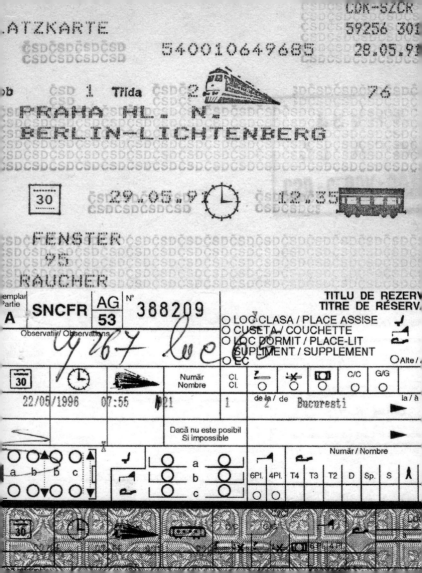

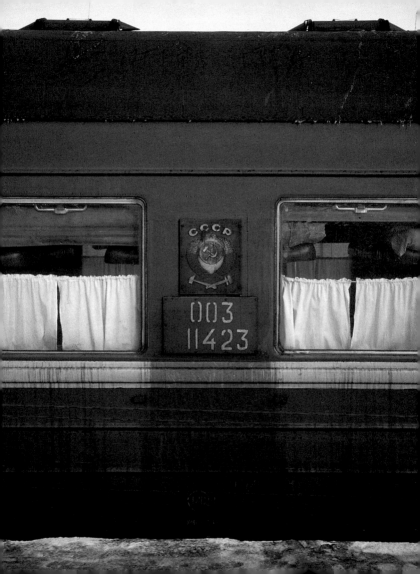

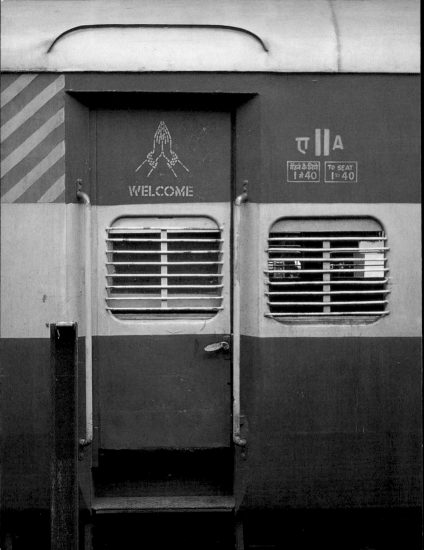

BATERIJ SUPPLEMENT

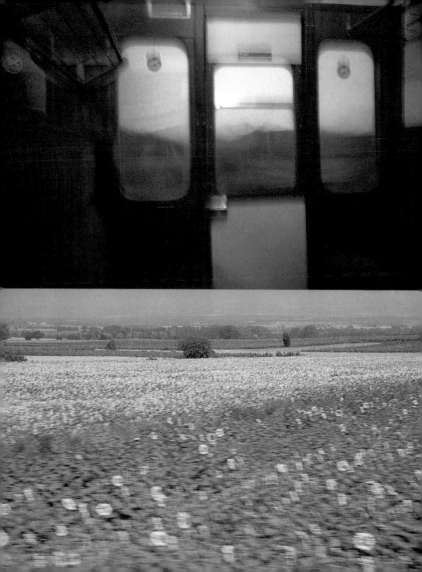

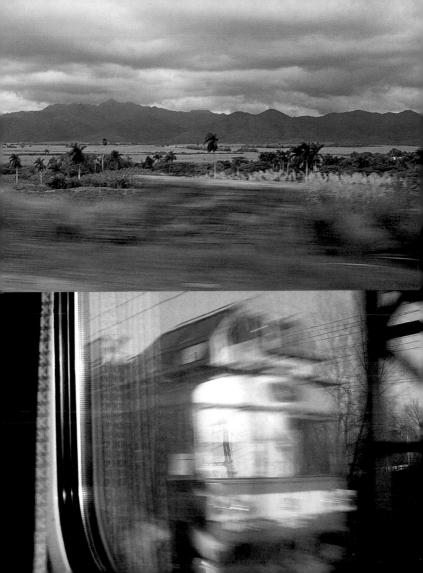

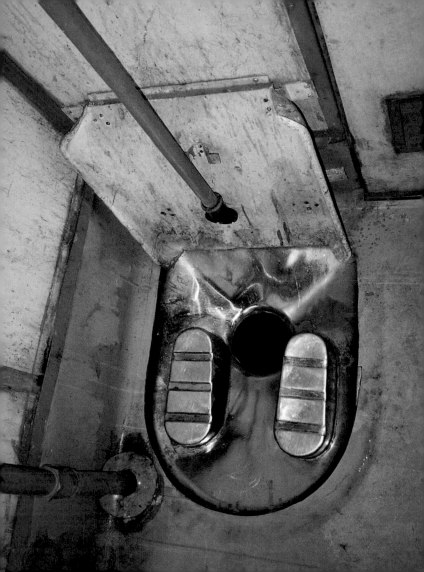

腰掛便器の使い方

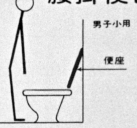

男子小用

便座

便座を上げて
使用してください

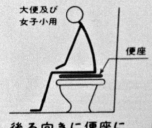

大便及び
女子小用

便座

後ろ向きに便座に
腰掛けてください

お 願 い
ご使用のあと　かならず
ボタンを 押してください
薬品の入った水が出ます
便器には 物を捨てないでください
（紙以外の物を捨てるときは左の箱の中へ）

143·71·330·175

505·161·79

ESTACION GOES
169·505·175
161·173

TERMINAL 3 CRUCES
143 71 330

HOSP. POLICIAL RONDEAU
173 191

GRAL. FLORES 169 505

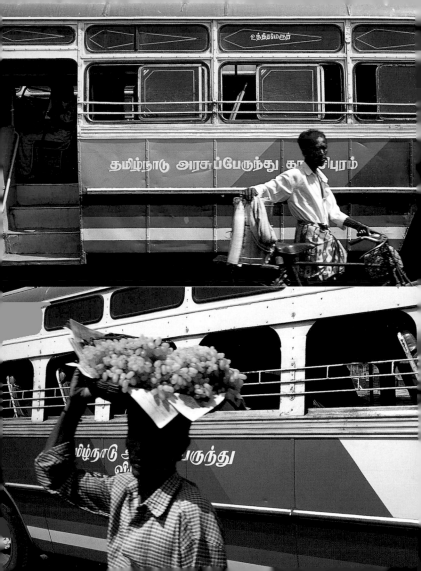

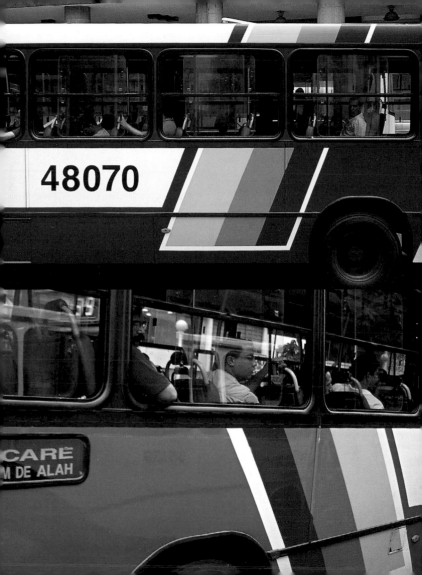

Vt 1797

NAIK	TURUN

7	(3 5)	1
6		2
5	SEN	3
4	DEWASA	4

МИНАВТОТРАНС

ПОЛНЫЙ БИЛЕТ

ДЕТСКИЙ I

От ст. _____

до ст. _____

ЖЕСТКИЙ АВТОБУС

Место № _____

Отпр. „_____" ч. „_____"

„_____" _____ 19___

Страховой сбор включен

639803 БИ

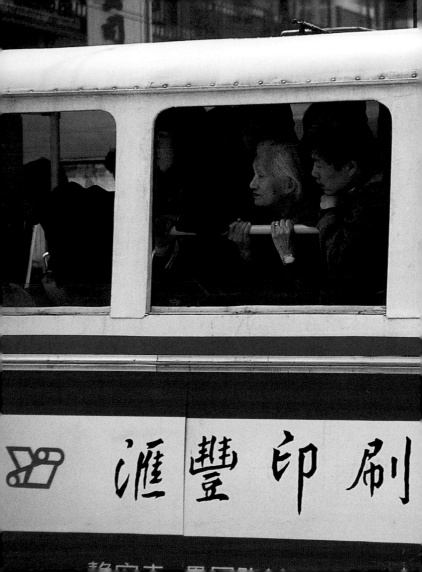

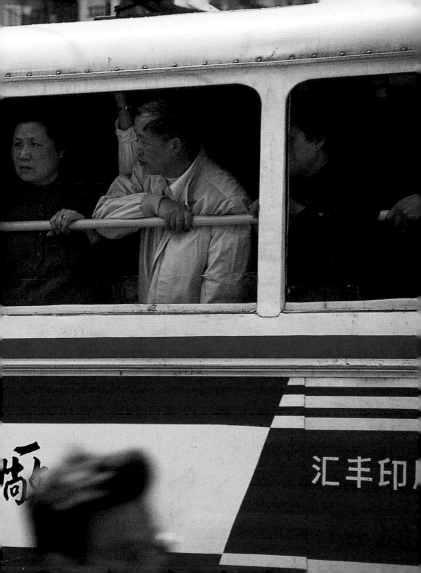

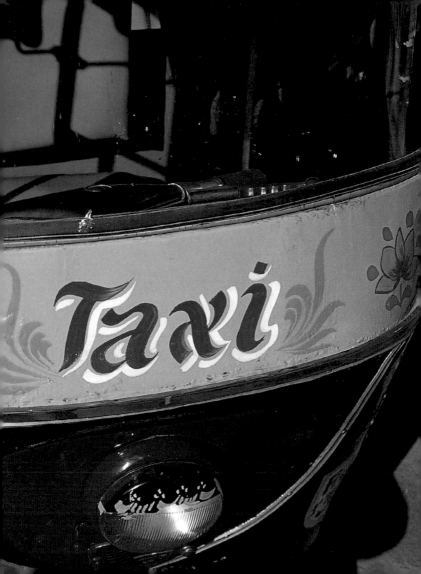

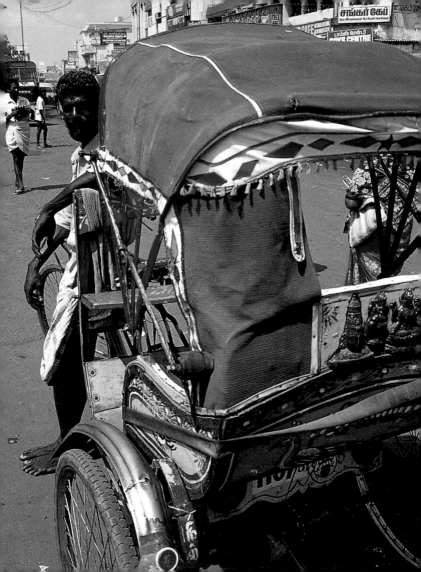

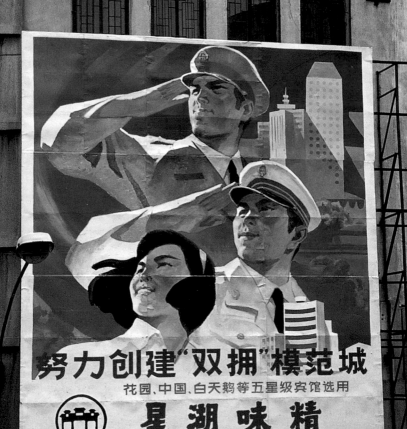

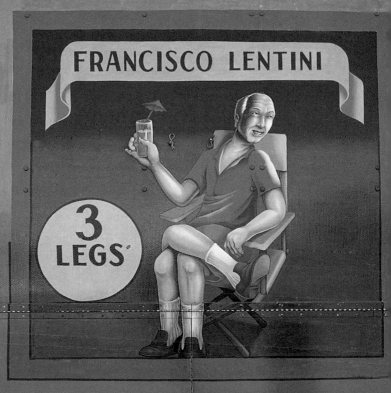

FRANCISCO LENTINI

3 LEGS

ODDITIES

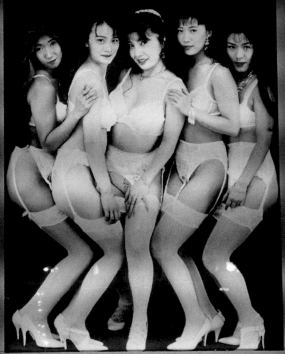

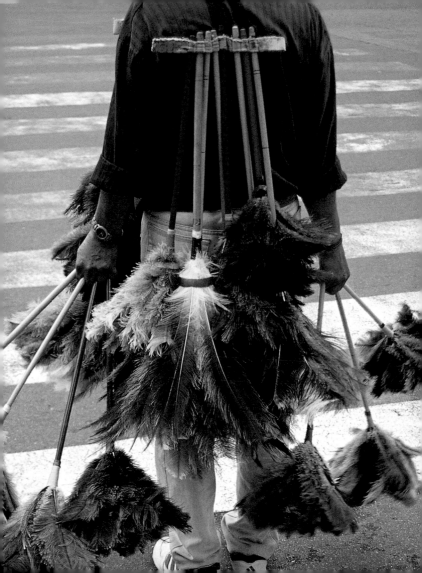

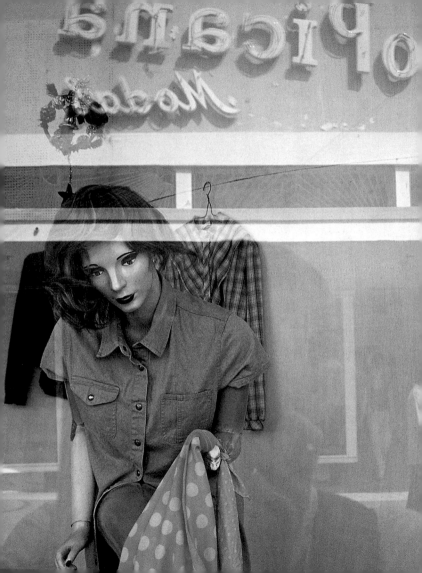

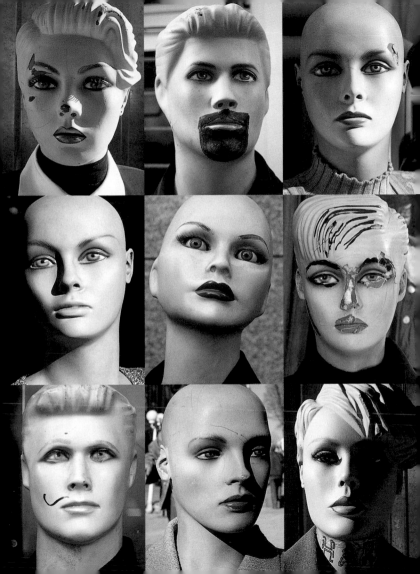

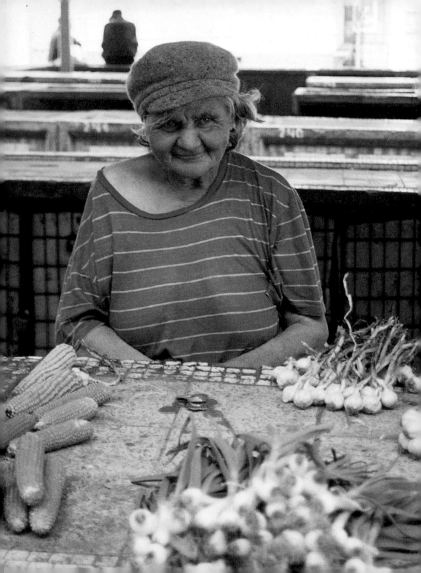

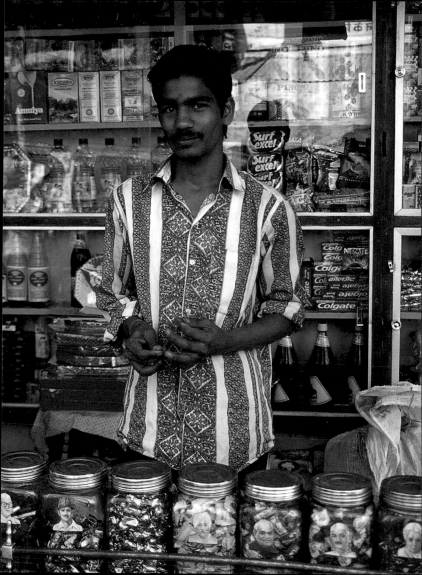

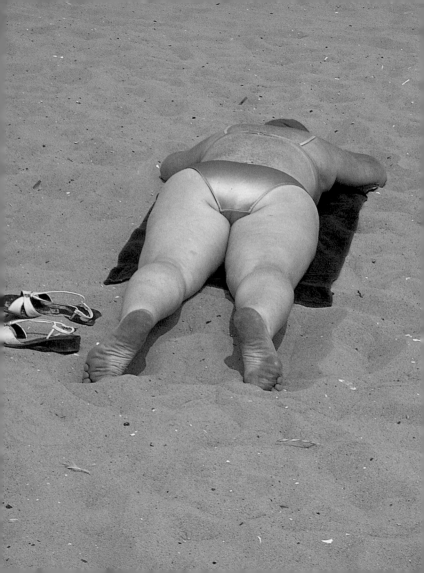

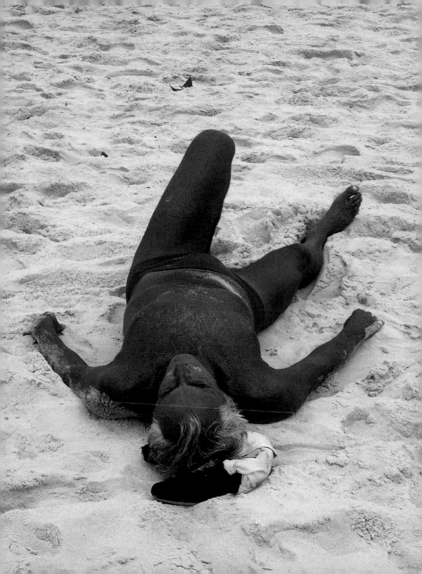

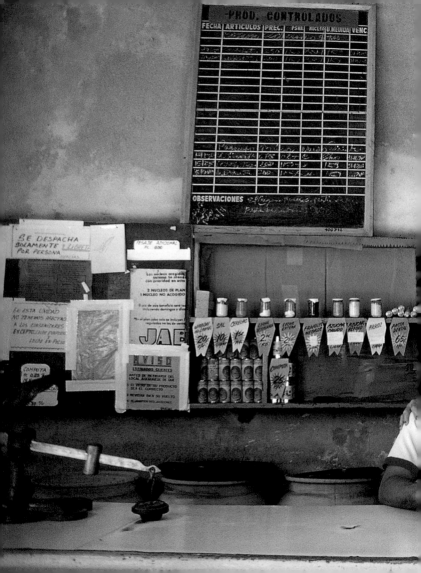

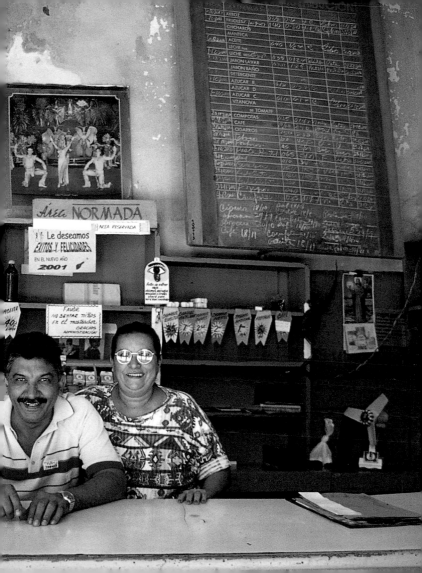

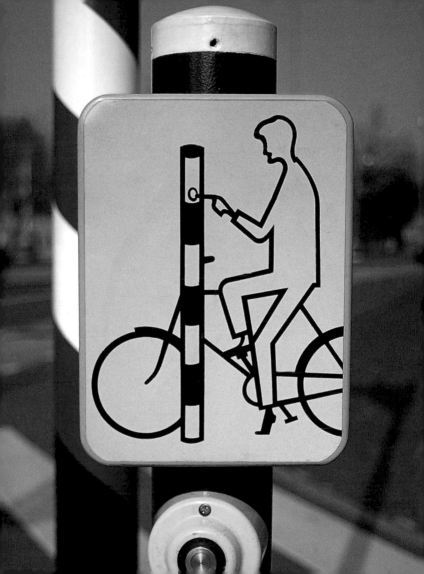

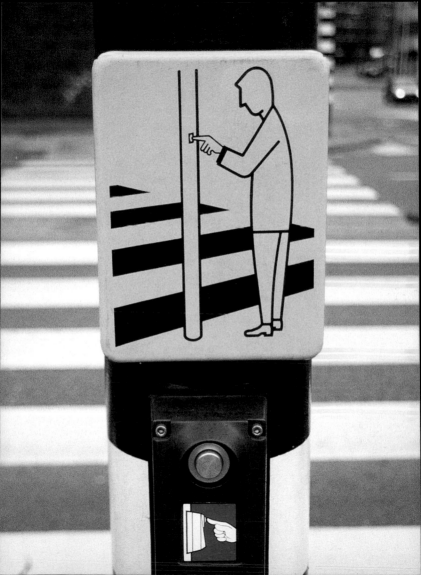

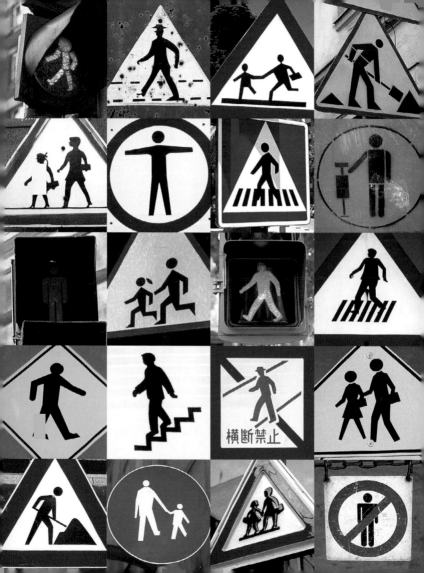

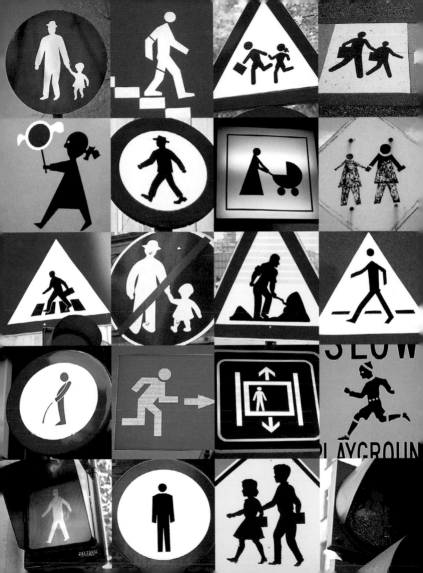

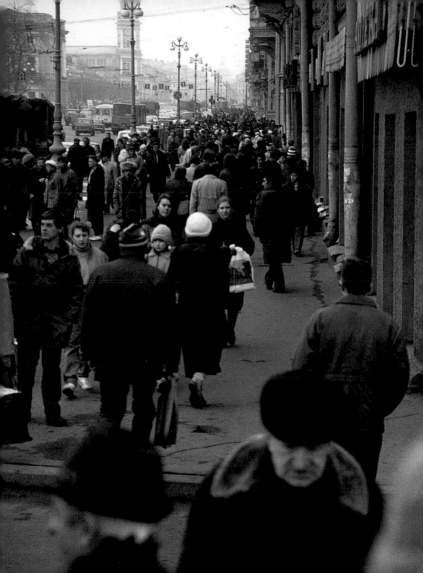

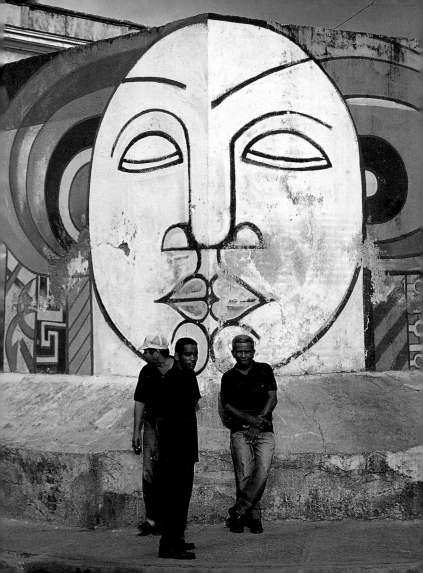

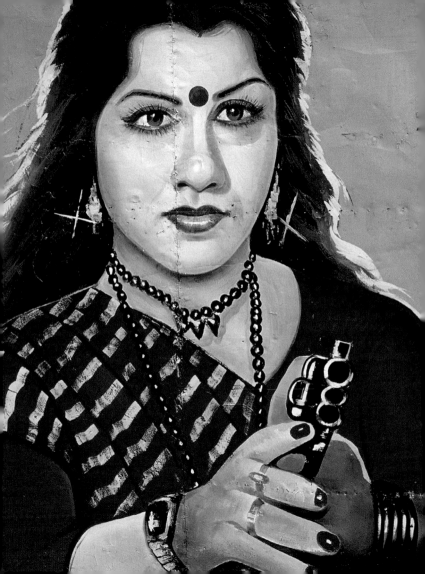

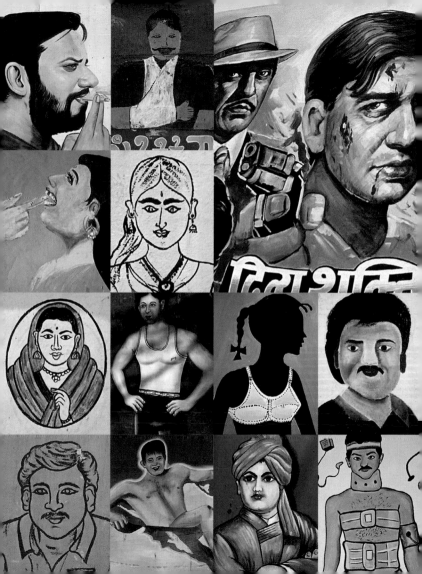

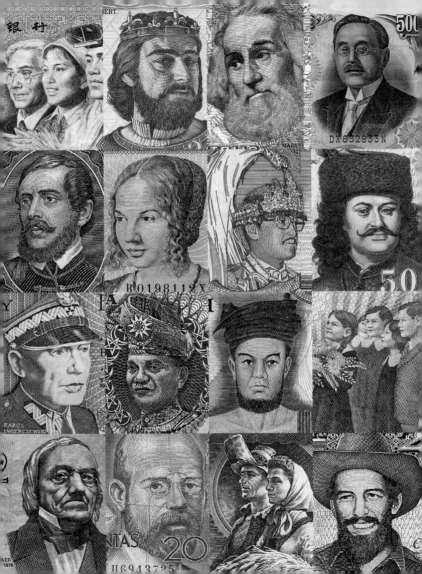

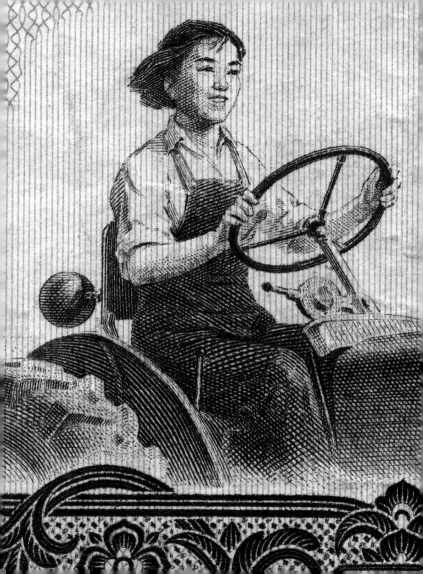

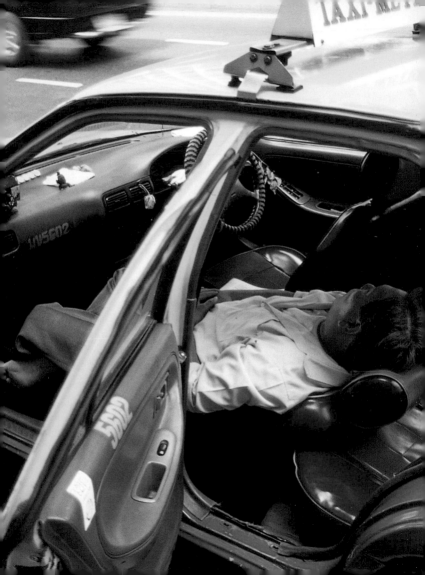

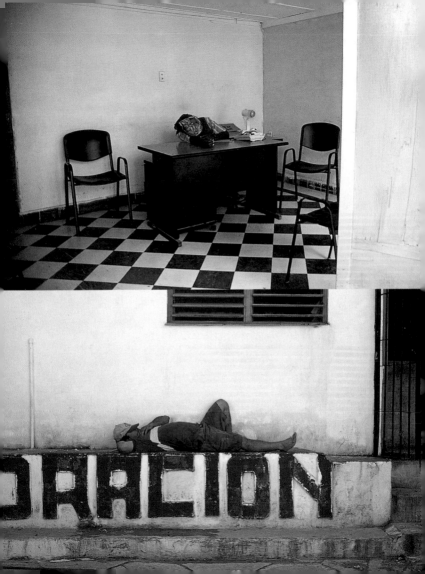

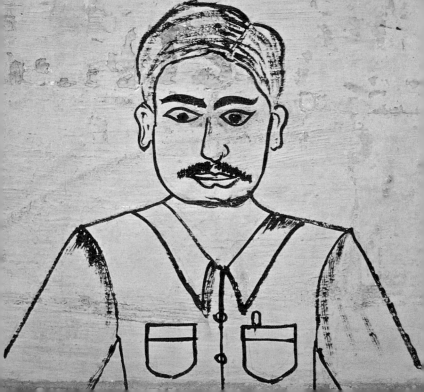

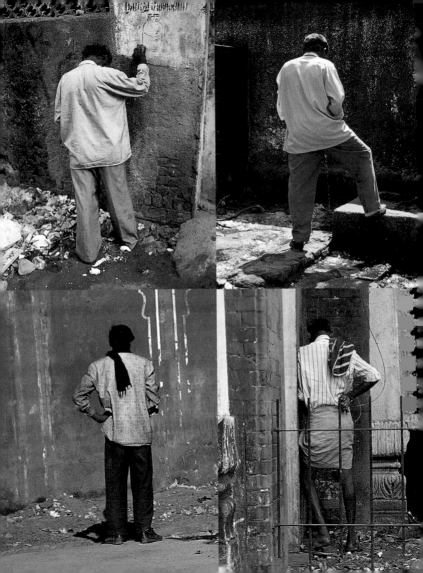

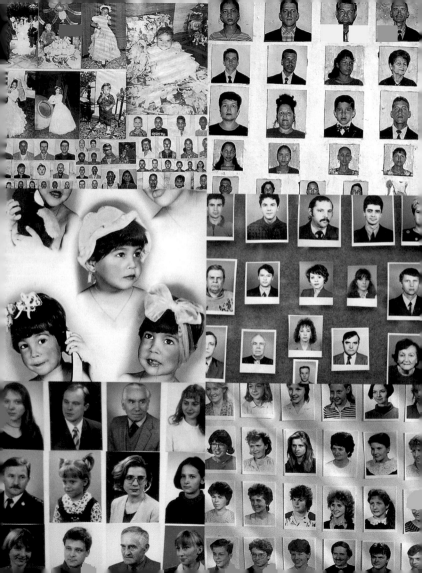

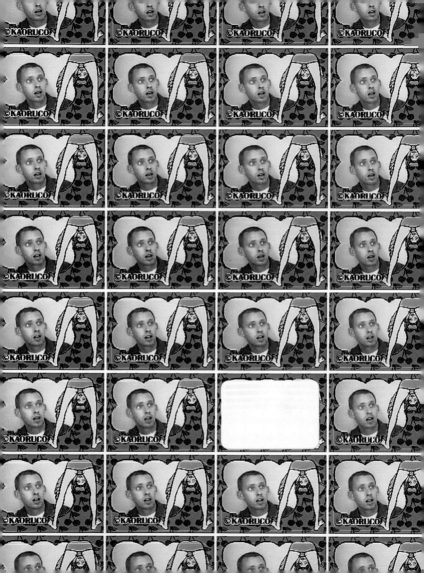

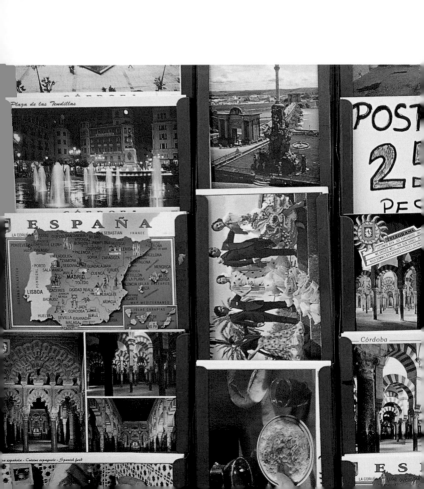

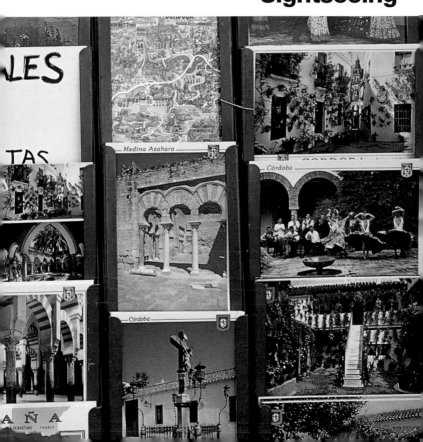

Wel-Come

WELCOME

TOURISTS
MOST
WELCOME

HOTEL
WELCOME

WelCome Saloon

WELCOME

PINK PANTHER
MAN & WOMAN
BOXING SHOW

MONDAY WEDNESDAY
FRIDAY SATURDAY
12.00 P.M

DAILY SIGHT

FLOATION MARKET

CITY & TEMPLE TOUR

GRAND PALACE & EMERALD

ROSE GARDEN & THAI CULTU

ANCIENT CITY TOUR.

CROCODILE FARM & ZOO.

AYUTHAYA ONE DAY TOUR &

ORIENTAL RICE BARGE.

THAI DINNER & THAI CLASSI

BANGKOK NIGHT TOUR.

RIVER KWAI TOUR & LUNCH.

WONDERFUL DINNER CRUISES

DAMNERNSADUK FLOATING MA

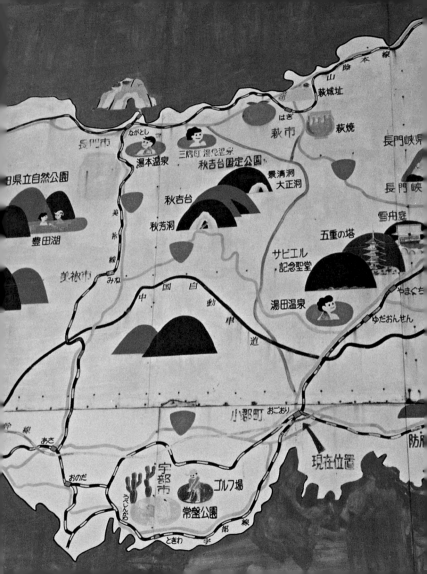

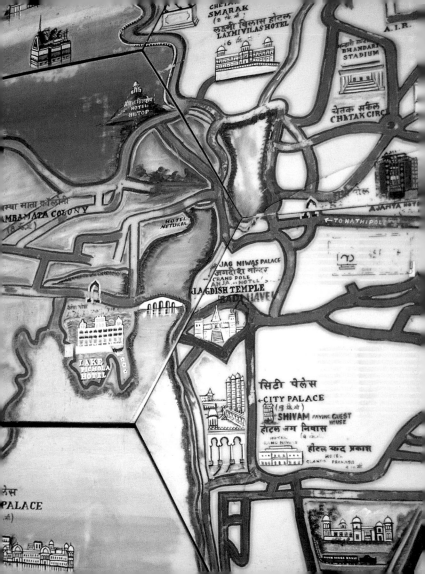

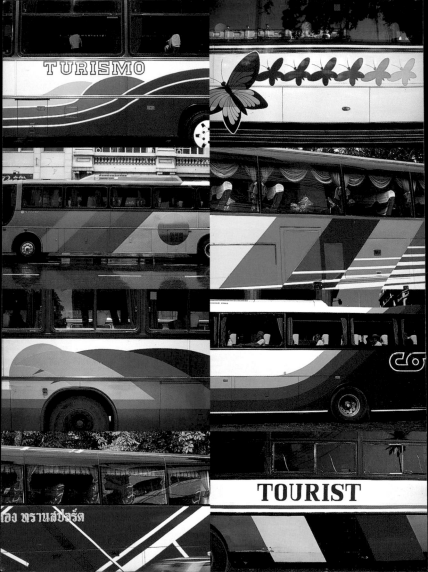

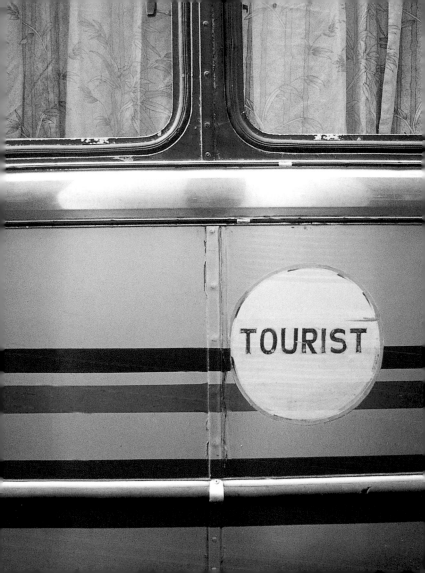

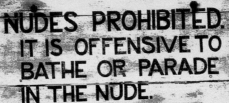

NUDES PROHIBITED.
IT IS OFFENSIVE TO
BATHE OR PARADE
IN THE NUDE.

DINAS PARIWISATA
DAERAH TK.I BALI.

PLEASE NOTE
THAT THIS IS
NOT A TOPLESS
BEACH
THANK YOU FOR
BEING CONSIDERATE
OF LOCAL FEELING

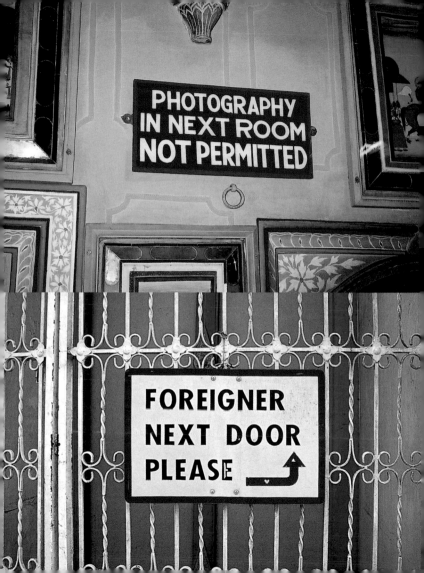

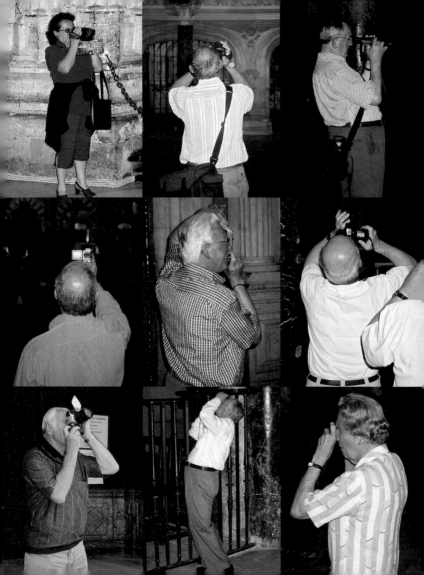

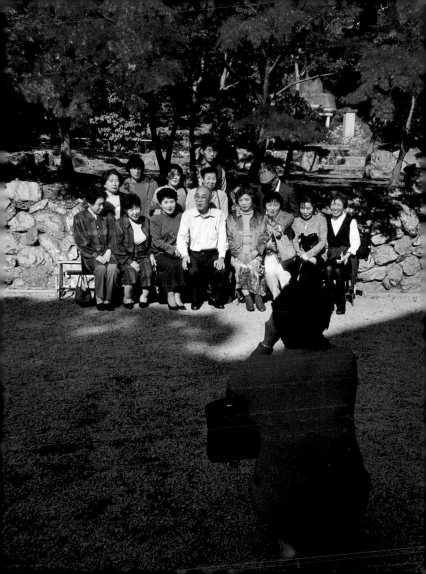

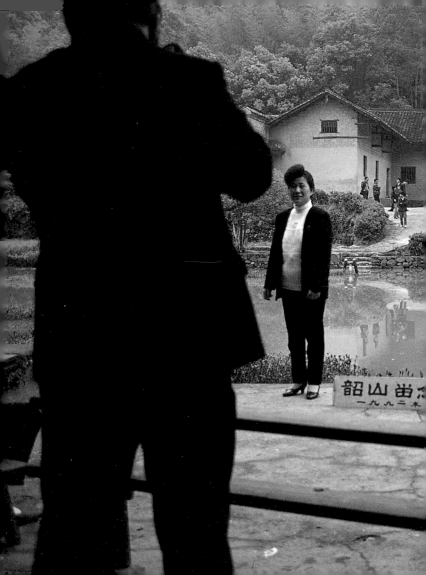

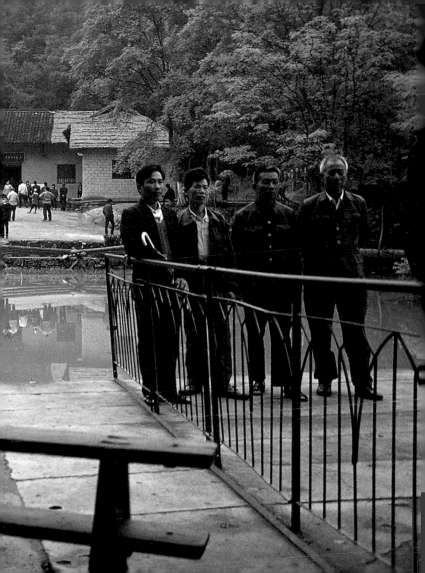

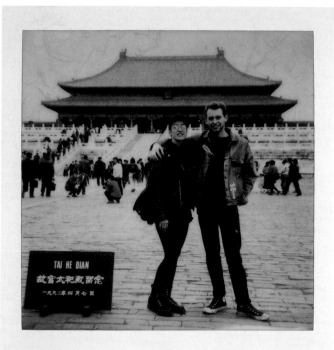

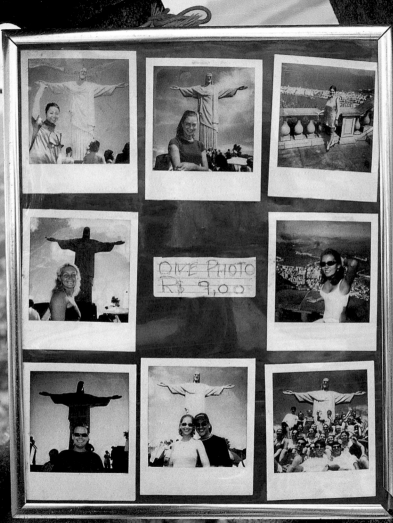

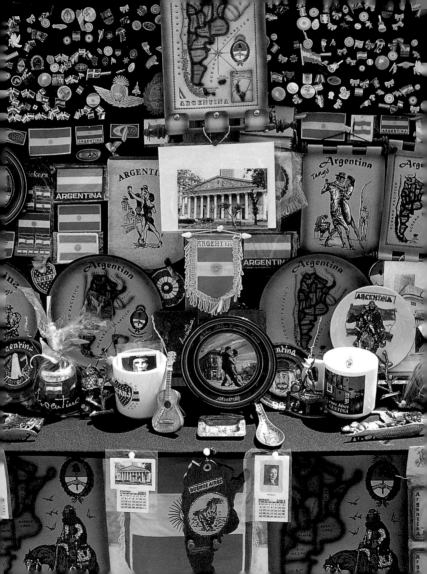

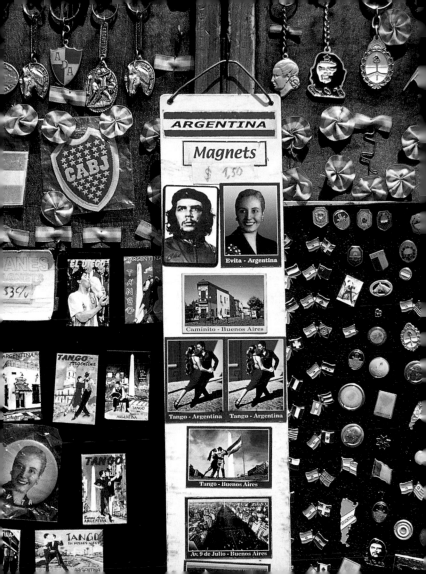

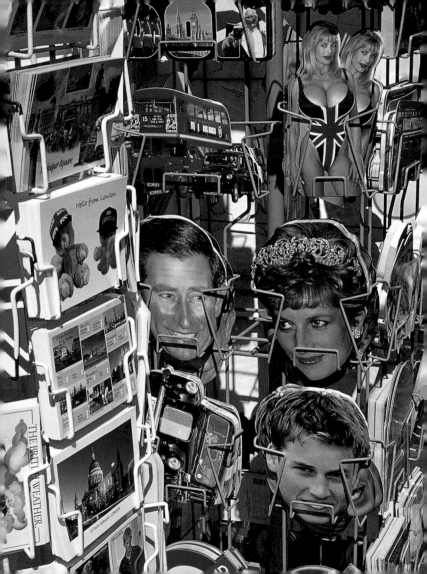

AIR MAIL
航空
AIR MAIL

AIR MAIL
PAR AVION

PRIORITY
AEROPHOST

PER LUCHTPOST
PAR AVION

AEROGRAMME
国际航空邮简

PER VIA AEREA
PAR AVION

R VIA AEREA
PAR AVION

AIR MAIL

MIT LUFTPOST
PAR AVION

快EXPRESS

航 空
PAR AVION

AIR MAIL
航 PAR AVION 空

VIA AIR MAIL

FLYGPOST·PAR AVION

УШНА ПОЩА

POR AVIÃO
PAR AVION

限 時 專 送
PROMPT DELIVERY

LÉGIPOS
PAR AVI

PAR AVION

PA

LÉGIPOSTA
PAR AVION

ABИA
PAR AVION

AV

PAR AVION

LOTNICZA
PAR AVION

PER LUGPOS
BY AIR MAIL
PAR AVION

PER LUC
AR AVI
MIT LUF

AIR
AVION

UÇAK İLE
PAR AVION

AIR MAIL

LUFTPO
PAR AVI
PRIORITA

EXPRÉS
IKA-EXPRESS

PAR AVION
AIR MAIL

By Air Mail
Par Avion

LUFTPOST
PAR AVION
VIA AEREA

BY AIR N
航 PAR AVI

PAR AVION
AEROPHOST
O.E. 78.

BY AIR MAI
PAR AVION

CHTPOST
AVION

航 空
PAR AVION

POS UDARA
CEPAT-TEPAT-AMAN

MEL UDARA
PAR AVION

BY

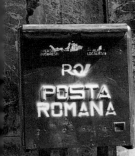
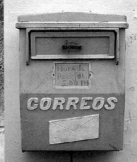
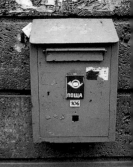

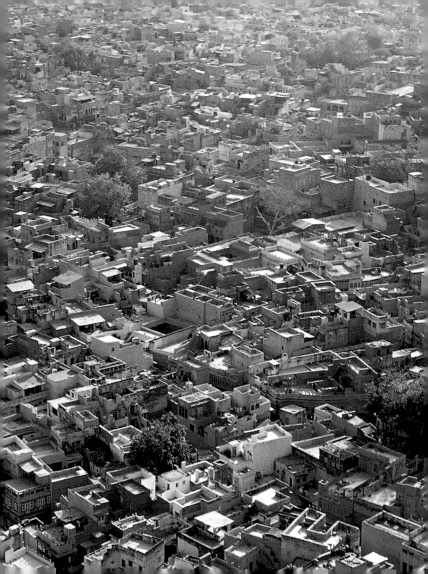

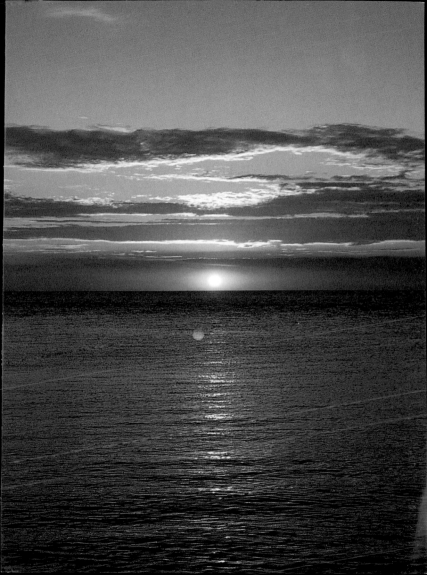

When I travel, the destination is not really
the point. I am fascinated by the transient
places of travel—the banks of TV screens
that hang from airport terminal ceilings
announcing departures to far-flung locales
around the globe, the ever-changing view
from a speeding train, ordering a meal from
an undecipherable menu, exploring the
subway beneath an unfamiliar city, waking
in another characterless hotel room that
could be anywhere, the tourist souvenir
vendors touting their wares.

Traveling faster and faster through this increasingly interconnected world, many of these everyday experiences that fill a journey get lost in the rush of getting from "You Are Here" to wherever you are going. But by opening yourself up to the rhythm and rhyme of the seemingly mundane details of travel, the familiar becomes unique, the ordinary extraordinary and the over-looked well worth a second glance.

This is what inspires me to travel. It's not about getting there, it's about all the fun you can have along the way.

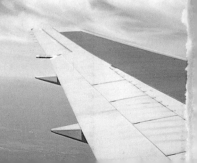

A big hearty thanks to all my friends and
family with whom I've had the good fortune
to travel alongside, travel to visit, been
inspired to travel by, or simply entertained
with postcards and e-mails and stories
upon return home. This could not have been
possible without you all.

DESTINATION
W A N D E R L U S T ✳ ✳ ✳

PHOTOS/DESIGN PUBLISHED BY
TROY M. LITTEN CHRONICLE BOOKS

Visit www.troyland.com for more Wanderlust.

Copyright © 2004 by Troy M. Litten.
All rights reserved. No part of this book may
be reproduced in any form without written
permission from the publisher.

Library of Congress Cataloging-in-Publication
Data available. ISBN 0-8118-4244-4

Manufactured in China

Book and cover design by Troy M. Litten
Author photos by Gabe Zichermann

Distributed in Canada by Raincoast Books
9050 Shaughnessy Street
Vancouver, British Columbia V6P 6E5

10 9 8 7 6 5 4 3

Chronicle Books LLC
35 Second Street
San Francisco, California 94105
www.chroniclebooks.com